LOOKING
WEST

Brock Silversides is Head Archivist of the Medicine
Hat Museum and Art Gallery. He has worked as an
audio-visual archivist for the Saskatchewan Archives,
the University of Saskatchewan, the National Library
of Canada, the Provincial Archives of Alberta, and
numerous private collections across Canada. He is the
author of several widely acclaimed books, including
*The Face Pullers: Photographing Native Canadians
1871-1939*; *Waiting for the Light: Early Mountain
Photography in British Columbia and Alberta 1865-1939*;
and *Shooting Cowboys: Photographing Canadian Cowboy
Culture 1875-1965*.

BROCK V. SILVERSIDES

LOOKING WEST

Photographing the
Canadian Prairies, 1858 – 1957

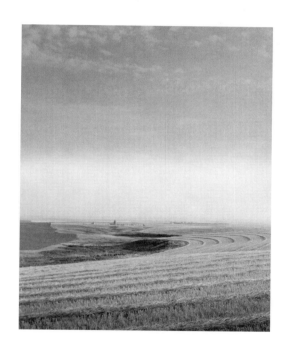

FIFTH
HOUSE
PUBLISHERS

Front cover photograph, "Swathed Field 15 miles west of Moose Jaw"
Southern Saskatchewan
September 1959
Olive B. Roberts / Saskatchewan Government Photo Services
Saskatchewan Archives Board, 59–706–01

Back cover photograph, "William Oliver photographing the Prairie"
Western Canada
c. 1925
Photographer unknown
Glenbow Archives, NA–4868–17

Cover and interior design by John Luckhurst / GDL

The publisher gratefully acknowledges the support of The Canada Council for the Arts and the Department of Canadian Heritage.

THE CANADA COUNCIL | LE CONSEIL DES ARTS
FOR THE ARTS | DU CANADA
SINCE 1957 | DEPUIS 1957

We acknowledge the financial support of the Government of Canada through the Book Publishing Industry Development Program for our publishing activities.

Printed in Canada.

99 00 01 02 03 / 5 4 3 2 1

Canadian Cataloguing in Publication Data

Silversides, Brock V., 1957–
 Looking west

Includes bibliographical references.
 ISBN 1–894004–09–4

 1. Prairie Provinces—History—Pictorial works.
 2. Photography—Prairie Provinces—History. I. Title.
 FC3237.S54 1999 971.2′0022′2 C99-910785-2
 F1060.5.S54 1999

Fifth House Ltd.
A Fitzhenry & Whiteside Company
#9 - 6125 11 St. SE
Calgary, Alberta, Canada T2H 2L6
1-800-387-9776

Contents

Acknowledgements

As is always the case with a compilation book, I have many people to thank. Tim Novak, a valued colleague at the Saskatchewan Archives, and Steve Luciuk of the Western Development Museum were unfailingly supportive in helping me find an array of interesting images. Elizabeth Blight at the Manitoba Archives, Cheryl Avery and Patrick Hayes of the University of Saskatchewan Archives, and Donny White of the Medicine Hat Museum and Art Gallery were generous with their knowledge of their respective photograph collections. Neil Richards of the University of Saskatchewan Special Collections, Doug Cass and Pat Molesky of the Glenbow Archives, and George Kovalenko of the Saskatoon Public Library's Local History Room were particularly helpful as well.

Thanks also to Kim Strange, Dave Leonard, Jim Tustian, Bill Marsden, Chuck Ross, Gerry Savage, George Buck, and Peter Silversides. Sincere thanks to Donald Ward for an insightful editing job. And for all her assistance and ideas, this book is dedicated to Laurel Wolanski.

Introduction

THE NEGLECTED ARTIST

Though endlessly beautiful to those who live here, the Canadian prairies have not traditionally been considered exotic or exciting by outsiders. Sadly, there are no "classic" Canadian prairie images, no photographs that are known to every school child and published in every historical study. But the prairies have a unique visual quality. It is a quality found nowhere else in Canada, arguably nowhere else in the world. The artists who documented the region—whether they worked in ink, paint, or photographic emulsion—had to develop new and different approaches to their task.

Few of the photographers represented in this book considered themselves "artists." They were quietly original, exploratory, thoughtful, and above all professional. They worked within the limits of geography, contemporary technology, and their clients' wishes. They spent most of their time recording the seemingly unremarkable daily lives of prairie people. But they knew when they had their lenses trained on something unusual, something important, some scene or event that was emblematic of the landscape.

With few exceptions, they did not trumpet their achievements. They were generally not even credited when their work was published. They were not public figures. There were no coteries, no artistic movements, no manifestos. They have never been considered a subject for serious academic research. Emphatically, they have never been accorded their rightful place in the history of Canadian photography.

Their images were created largely for utilitarian purposes: surveying, exploring, documenting natural resources, journalism, advertising and boosterism, scientific research (especially in the fields of agriculture and horticulture), documenting government programs and corporate activities. In many cases, they were commissioned by patrons who wanted to attract investment or tourists—or, on a more personal level, to impress the folks back home, to show that they had established themselves in the new

territories and life wasn't that bad. In the process, and perhaps unknown both to them and to their clients, they created many images of profound artistic significance.

A remarkable body of work has been created over the past 140 years by a large number of prairie photographers, and they should not remain anonymous. If only as creators of valuable historical documents, they should be brought into the spotlight. As visual artists, we should know who they were, why they worked (and for whom), what the prevailing artistic and commercial trends were, and what they could accomplish with their limited technology. Appreciating these things can only lead to a greater understanding of the images themselves.

Prairie photographers have always been a hardy bunch, almost by definition. Ease and comfort have never been synonymous with prairie life, and prairie photographers have had to overcome countless obstacles in securing their images. The first impediment, of course, was the weather. A photographer had to endure burning summers with little shade, and bone-numbing, bellows-cracking winters. The dry cold created static streaks and flares on unexposed plates. It cracked glass plates and rolled films, and numbed exposed fingers in seconds.

The wind, too, was more than merely an irritant. It blew dust, sand, and topsoil into film holders, cameras, and lenses. It turned dust storms and fires into high-speed rampages, broke windows and skylights in studios, and regularly mowed down the tents of itinerant photographers. The *Moose Jaw Times* of 16 June 1893 reported the "blowing down of Mr. J. A. Gould's photograph tent, and the removal of two or three outhouses from various parts of the town," and the *South Edmonton News* reported on damage done to travelling photographer F. L. Lemon on 14 May 1896: "Tents have gone down—at least F. L. Lemon's has—yesterday's heavy wind did it. Other slight damage was also done here and there."

On 3 December 1885, Fort Macleod was hit by a cyclone, which, according to the *Macleod Gazette*, caused "a

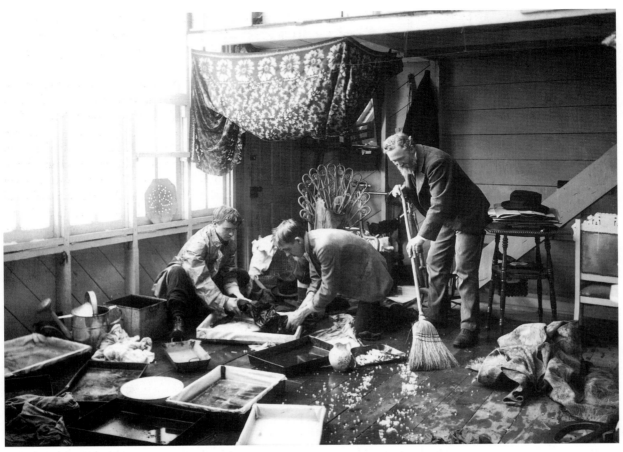

"Interior of a North Western Photograph Gallery after a Hail Storm"
Location unknown
Frederick Steele / Steele & Co. / 1890s
SASKATCHEWAN ARCHIVES BOARD, R–B1549

remarkable disturbance among loose articles such as barrels, wagons and small boys." Windows were broken, freight wagons overturned, chimneys crumpled, and fences blown down. "Doubtless if one searched thoroughly, pieces of British Columbia might be found in Macleod," the story continued. "Two doors west of the Gazette office is A. H. Anderton's photograph gallery. The roof of his place was blown clean off and deposited up against the fence of his office, a distance of thirty or forty yards."

A problem that every prairie inhabitant complained about was doubly irritating to the photographer. Flies and mosquitoes plagued the photographer at work, biting hands and faces, even eyelids, making focusing difficult, if not impossible. Insect bodies contaminated processing chemicals and wet plates, and periodic infestations of locusts did nothing to ease the task.

Most Western photographers were forced to travel widely to build their clientele and generate an adequate income. For most of the 19th century and at least the first half of the 20th, there were few adequate roads. Those that did exist were frequently rough grids, meandering off into prairie gumbo, which in inclement weather was remarkably similar to quicksand. Road maps, which themselves meandered off in two dimensions, were not really useful until the 1920s. A photographer on horseback or in a stagecoach who was not thoroughly familiar with the township grid would get lost more easily than not. Rivers were wide, bridges were few, and ferries were not always reliable.

Imagine the adventures awaiting William M. Tegart, an enthusiastic young photographer who left Battleford for Edmonton in September 1898, intending to make the journey on his bicycle.

Much of the water supply in small towns and farming districts came from nearby lakes or underground wells, most of them rich in minerals, including alkali, sulphates, hydroxides, iron salts, and nitrates. While acceptable for drinking, the water was far from suitable for photographic processing. Contaminants in the water weakened or neutralized developers and fixers. Consequently, many photographic plates and prints processed in rural areas show signs of weak development, fading, silvering, and instability.

Fire was a constant danger—and not just prairie fires. Magnesium powder was ignited as a flash for indoor photography, and other early photographic materials and processing chemicals were highly flammable. From the 1920s to the 1950s, most photographers used film that had a base of highly combustible cellulose nitrate. If negatives were stored beside lanterns, fireplaces, coal-burning stoves, or furnaces, there was a real possibility of their igniting. A significant number of prairie studios succumbed to the flames. As the 24 November 1898 issue of the *Saskatchewan Herald* reported, "On the morning of the 14th, a fire broke out in a photographer's rooms over Mowat Bros. and Baxter's store, Regina, and before it could be extinguished had destroyed the entire range of twelve business places on the block between the railway depot and the Windsor Hotel."

In its 29 June 1897 edition, the *Lethbridge News* reported:

Mr. W. A. McBean's photograph gallery, on the bottom near the site of the old sawmill, was totally destroyed by fire on Monday morning at 3 o'clock. Owing to the early hour and the rapidity with which the flames spread no assistance could be rendered, and the fire had gained such headway when discovered that the occupants had only time to save a few articles of wearing apparel and a couple of trunks. The contents were a total loss . . .

But by far the greatest obstacle facing prairie photographers was the lack of customers. This was owed partly to the small and widely scattered population, and partly to the lack of disposable income among that population. Family gatherings and community events were often on such a small scale that the financial rewards to the photographer were minimal. The lack of hard cash among the farming community meant that rural photographers were frequently paid for their services with milk, produce, or chickens.

Not surprisingly, a large number of Western photographers had to take other employment to make ends meet. John Voights of Gretna, MB, was a bookseller; the Best Brothers of Winnipeg were in real estate; Mrs. Charles F. Kreiger of Souris, MB, taught music; Arthur O'Kell of Maple Creek, SK, was a recorder of cattle and horse brands; J. H. McCall of Oxbow, SK, was a grocer; William Johnson of Selkirk, MB, was a jeweller; Harry E. Belyea of Scott, SK, practised dentistry; Cornelius Soule of Regina and Calgary was an architect; William James of Prince Albert cut hair and operated a bath house; T. B. Henderson of Edmonton was a tailor and sold sewing machines; Alexander Ross of Calgary was a dealer in pianos; David Cadzow was an itinerant working in Battleford and Edmonton, as well as a trapper; A. B. Szekely of Kipling, SK, ran a dance hall; John Brittan of Grenfell, SK, operated a pool hall; the itinerant photographic team of Mr. and Mrs. Kendricks were also hypnotists; George Anderton of Fort Macleod, AB, managed a saloon and a bathhouse; J. A. Brock of Brandon sold trees; Ernest Brown ran an "Old West" museum in Edmonton; Frank Mills of Carlyle, SK, was a pharmacist; George Fleming worked on a fox farm near Red Deer; Donald Buchanan of Arcola, SK, was a woodcarver; Shorney and Miller of Balcarres, SK, were cleaners and pressers; and William P. Bate of Saskatoon was a schoolteacher.

The audience for photographs was generally unappreciative. This was partly owing to the assumption—widely held to the present day—that photographs of the prairies were all alike. They were dull. Most people travelling through the region, whether on the train or by automobile, just wanted to pass through as quickly as possible, preferably by night. Those from outside the region, and many living in it, were convinced that the entire area was one long piece of unrolled carpet from the Red River to the Rocky Mountains, with no geographical features to speak of. In their minds all prairie residents—except, perhaps, First Nations—looked alike; all prairie structures were small, unassuming, utilitarian.

Those who bothered to look, of course, saw rivers, valleys, creeks, buttes, coulees, and lakes; they appreciated the different ethnic groups, their clothing and customs, the tipis, sod huts, barns, grain elevators, false-fronted stores,

churches, and vistas down Main Street and Railway Avenue. These few in the know, however, were too far between to change minds.

Westerners—being parsimonious, self-made, and independent at heart—have always begrudged paying for something they can do themselves. Many prairie people felt that, as anyone could take a photograph, why should they hand over money to someone who just had more time to do it? That practicality also limited the types of photographs that were taken: pictures of the family or the farm might be justifiable, but a study of clouds would not be appreciated or have much of a market.

Finally, there was—and remains—the assumption that a photographer who voluntarily lived and worked on Canada's western frontier was somehow an inferior artist. ("If you're so good, what are you doing in Saskatchewan?") The attitude originated with superior central Canadians, but it found fertile ground in the subtle prairie inferiority complex. With an unbiased look at their work, however, and with a knowledge of the hardships they endured, any objective observer can easily see that these photographers were as talented as any less-adventurous central Canadian, American, or European artist who chose to stay at home. Indeed, considering the physical and commercial hardships and the indifference of the local population, prairie photographers were likely possessed of a greater dedication and ingenuity than any established studio operator on Yonge Street.

EXPLORERS AND SURVEYORS

In the mid-1850s the Hudson's Bay Company was lobbying for an extension of its monopoly in Rupert's Land, which was due to expire in 1859. At the same time, the new Canadian government was eyeing the area—which included approximately 110 million hectares of prairie—for expansion.

It was obvious to the government that settlement was not only possible but desirable; this was amply demonstrated by the half-century experience of the Red River Colony. For further confirmation, however, the area had to be studied in detail. In 1857, two exploratory expeditions were sent to the prairies, one sponsored by the British government and headed by Captain John Palliser, the other sponsored by the Canadian government and led by Henry Youle Hind, a respected academic from the University of Toronto. Palliser did not take a photographer. Hind, on his second trip, wisely, did.

His choice was Humphrey Lloyd Hime, a partner in a Toronto firm of "Civil Engineers, Draughtsmen, and Photographists." Born in 1833, Hime had immigrated to Canada in 1854 and worked on a survey crew on Ontario's Bruce Peninsula. In 1857 he joined William Armstrong and Daniel Beere, both reputable photographers. By early April 1858, Hind had finalized the personnel for his second expedition. Of Hime, he wrote:

> Mr. Hime is a practical photographer of the service of Armstrong, Hime and Beere, Toronto. In addition to the qualification of being an excellent photographer, he is also a practical surveyor, and it is understood that when his services are not required for the practice of his particular department, he is to assist in the surveying operations. Mr. Hime will furnish a series of Collodion Negatives for the full illustration of all objects of interest susceptible of photographic delineation, from which any number of copies can be taken to illustrate a narrative of the Expedition and a report on its results.

The journey started from Toronto on 29 April by way of Detroit, then by steamer across Lakes Huron and Superior to Grand Portage. From there, it took twenty-eight days to reach the Red River by canoe. Just prior to reaching the settlement on the Red River on 1 June 1858, Hime took a picture of the company's guides. It was the first photographic image ever taken of western Canada.

The first order of business was to explore the environs of the Little Souris Valley, and the party spent the rest of June crossing the "Great Prairie" to Fort Ellice at the meeting of the Qu'Appelle and Assiniboine Rivers. Typically, thunderstorms alternated with excessive heat, which produced perfect conditions for breeding mosquitoes and grasshoppers. "Everywhere we find grasshoppers," Hind wrote:

> innumerable hosts of grasshoppers were flying northward in the direction of the wind. At times they would cast a shadow over the prairie, and for several hours one day, the sky from the horizon to an altitude of thirty degrees, acquired an indescribably brilliant and white tint, and seemed fairly luminous as the semi-transparent wings of countless millions of grasshoppers toward the north and northeast reflected the light of the sun.

Unfortunately, the photographic technology of the day was not sensitive enough to capture the moment.

By mid-July, they had reached the Fishing Lakes in the Qu'Appelle Valley, and Hime produced the first photographs taken in what would become Saskatchewan. Hind was impressed, writing in his journal, "two excellent photographs, taken near the [Anglican] Mission, of the lakes and hills, display the chief characteristics of the valley with the fidelity which can only be attained by that wonderful art."

The surveyors went on to Long Lake, then cut east overland to Fort Pelly. Hime's notebook complains of "stinking pools," more mosquitoes, more grasshoppers, and meals of eaglets and skunk. By the end of July they were on the Whitesand River, and the transport wagon tipped over during the crossing. "I had the satisfaction," reported Hime wryly, "of seeing my Photographic Apparatus, my gun, my clothes and all my Penates submerged."

From Fort Pelly, they carried on down the Assiniboine River to the Whitemud River, Shoal Lake, and back to the Red River Colony, where Hime stayed for a month and a half, "executing a number of photographs of scenes, churches, buildings, Indians, etc. which will form an interesting collection." Among these was the stunning minimalist image, "The Prairie—Looking West."

It is estimated that Hime took a total of three dozen photographs on this expedition. Of these, no negatives have survived, and only thirty-five print images. But his achievements were remarkable, especially when one realizes he was using the wet-plate process, a complex and cumbersome method that involved the production of a negative on a glass plate. The photographer had to coat the plate with a collodion emulsion, then dip it in a solution of silver nitrate. The plate was then slipped into a dark slide, brought to the camera, exposed, and processed before the emulsion dried. The process required immediate access to a darkroom and chemicals. Hime thus had to convey heavy glass plates, a black tent, the necessary chemicals and water, and a large box camera throughout the expedition. It is a wonder that any of his images survived.

Hime made up a set of prints in Toronto over the winter of 1859 to accompany Hind's final report and to include (as chromolithograph reproductions) in the two-volume popular account *Narrative of the Canadian Red River Exploring Expedition of 1857 and of the Assiniboine and Saskatchewan Exploring Expedition of 1858* published in London. The *Nor'Wester*, a Winnipeg newspaper, announced the book on 28 May 1860:

The Canadian Government having despatched in the years 1857 and 1858 two expeditions, at a cost of $12,000, for the exploration of the southern portion of Rupert's Land, between the boundary line, the Red River, and the Rocky Mountains, including the region traversed by the overland route from Canada to British Columbia . . . with a view to the formation of a new colonial settlement. The narrative of these expeditions, drawn up by Mr. Henry Youle Hind, M. A., Professor of Chemistry and Geology in Trinity College, Toronto, who had charge of the second expedition, is preparing for publication by Messrs. Longman and Co. . . . The work will contain ample particulars of the physical geography, geology, and climate of the territory explored; and will be embellished with coloured maps, geographical and geological, and numerous other illustrations, including striking waterfalls and other picturesque mountain and river scenery, prairie animals, portraits of the red natives and Halfbreeds, and several fossil remains new to science.

The book sold well, and encouraged interest in the Canadian prairies—which was its purpose, after all. Hime left his firm shortly afterward, and spent a colourful career in business and public service before dying in 1903.

In 1871 British Columbia entered Confederation on the understanding that a transcontinental railroad was to be completed by the Canadian government within ten years. Sandford Fleming, chief engineer of the Canadian Pacific Railway, started surveying possible routes across the prairies that summer. One of the men he hired as surveyor and photographer was Charles Horetzky, an ambitious Scot of Ukrainian descent. Born in 1840, Horetzky had immigrated to Canada in 1858, and started his career with the Hudson's Bay Company at Fort William and Moose Factory.

His first expedition started from Fort Garry in August 1871. It followed the Assiniboine River west, turned north to Fort Pelly, then west again to the Elbow of the South Saskatchewan River. Horetzky took a side trip to Fort Carlton in September, securing a number of attractive views of the Saskatchewan River valley. Continuing on to Fort Edmonton, he again split off from the main party and headed for Rocky Mountain House and Jasper. Wintering in Fort Edmonton, he managed to produce several scenes in the sub-zero temperatures—only possible because he

was the first photographer on the prairies to use pre-coated gelatin emulsion dry plates. Had he been using wet plates, they would have frozen before being exposed.

The second expedition started in August 1872, with stops at Forts Ellice, Carlton, and Pitt, and again Fort Edmonton. Horetzky and John Macoun arranged a side trip to explore the Peace River country via Lesser Slave Lake and Dunvegan.

In his final report, Horetzky promoted the Pine River Pass north of the Peace River as the most appropriate point to cross the Rocky Mountains, and was promptly fired for his recommendation; the CPR subsequently chose a more southerly route. While most of Horetzky's later career was centred on the interior of British Columbia, it is his two years on the prairies that has secured his reputation as a photographer. Several of his images were used as illustrations in George Grant's best-seller, *Ocean To Ocean* (1877), and he later wrote two books of his own: *Canada On The Pacific* (1874), and *Some Startling Facts Relating To the Canadian Pacific Railway and the North-West Lands* (1880).

Rupert's Land became part of Canada in 1870. Although it was agreed that the lower limit of the new territory, the 49th parallel, was the border between prairie Canada and the United States, it had never been surveyed or marked. A decade earlier, an American-British bilateral boundary commission had determined the international border from the Pacific Ocean to the eastern slope of the Rocky Mountains, and photographers on the project had provided useful documentation of the process and of the country they passed through.

In 1870, the American General George Sykes conducted his own survey of the 49th parallel. Not surprisingly, his line meandered far north of the traditional border. It soon became apparent that it was in everybody's interest (save Sykes's) that another joint commission be activated. Consequently, the second North American Boundary Commission was established in 1872 with a mandate to determine and mark the international boundary from Lake of the Woods to the eastern slope of the Rockies. The mostly British contingent of forty-four Royal Engineers was under the leadership of Donald Roderick Cameron, the son-in-law of future Prime Minister Sir Charles Tupper.

Four of the men were photographers, including J. McCammon, G. Parsons, and Samuel Anderson. In the

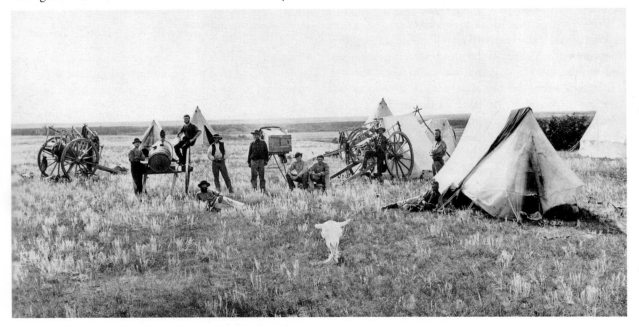

"Serg. Kay's R. E. Survey Camp on N. Antler River"
North Antler River, SK
Royal Engineers / North American Boundary Survey / 1873
NATIONAL ARCHIVES OF CANADA, C–73303

second year, images were taken by Canadian George M. Dawson who had signed on as a naturalist. Their photographs, they were told, "should be confined to points of scientific interest or such as may be usefully illustrative of the progress of the Commission." After documenting the operations of the commission, which included building mounds, constructing bridges, and gathering buffalo chips for fuel, the photographers proceeded openly to ignore their prime directive. They shot a wide variety of subject matter, from river ice to spring floods and paddle steamers, from group portraits of the Métis guides to candid shots of First Nations people. Their work today provides an invaluable record of the prairies prior to European settlement.

The commission, having surveyed and marked over a thousand miles in two years, finished its work in November 1874 at Waterton Lake in southern Alberta. Its correspondence and reports were liberally illustrated by the four photographers' exhaustive and imaginative work.

Before the Canadian Pacific main line was completed, the railway was gathering information about possible branch lines. In the summer of 1883, it mounted an expedition under the direction of C. A. Kenaston to explore the country north of the main line. The *Saskatchewan Herald* announced Kenaston's arrival at Battleford in August:

> Prof. Kenaston passed several days here last week. He is engaged by the Canadian Pacific Railway Company in making an examination of the land lying to the north of the railway. He first made a thorough examination of the country between Swift Current, on the main line of the CPR and Edmonton, having crossed the South Saskatchewan below the Red Deer Forks, thence via Sounding and Sullivan's Lakes to Buffalo Lake, Battle and Red Deer Valleys, and along the fifth principal meridian to Edmonton. He then went to near Athabasca Landing, and across country to Victoria and down the north side of the north Branch to Battleford, making numerous and extended excursions off the line of travel.

Walpole Rolland, a "photographic artist," accompanied the professor, the paper reported:

> in addition to sketching the general features of the country he takes photographic views of the principle points of interest along the route. While here he took a number of views of the town from different standpoints, and pronounces the town site and its surroundings to be the most picturesque and well situated of any in the country.

Little is known about Kenaston or Rolland—or the survey, for that matter—though their findings may have influenced the CPR to establish its two major branch lines of the 1890s: the Qu'Appelle, Long Lake, and Saskatchewan, linking Regina to Prince Albert, and the C & E, linking Calgary and Edmonton. Kenaston published only one article dealing with his experiences, "The Great Plains of Canada," which appeared in *The Century Magazine* in 1890.

A huge proportion of prairie photographic documentation was produced by the longest-standing scientific agency of the federal government, the Geological Survey of Canada. It was established in 1842 to explore, describe, and map the natural resources, climate, soils, forests, water, wildlife, fossils, navigation, and First Nations of the new country. The GSC made its operations known to the public by ongoing publications, national and international exhibitions, and operating what would eventually become the Museum of Natural History.

Its activities, intermittent at first, became increasingly professional and wide-ranging after 1870 when the Hudson's Bay lands became part of Canada. The federal government was formulating a settlement policy for the new territory, and the prairies were first in its line of sight. Accurate and current information was crucial in deciding which areas could accommodate settlers first, the most suitable route for a transcontinental railway, and the likeliest locations for resource development.

Starting in the summer of 1873, when the director of the GSC, Alfred Selwyn, traversed the prairie region from Winnipeg to the Rocky Mountains and back in a Red River cart, the agency sent out annual exploratory teams from its headquarters in Montreal, then Ottawa. Most of the officers of the Geological Survey received some degree of training in photography, and were encouraged to utilize it during their field trips.

As photographic equipment became more portable and convenient, Morris Zaslow explains in *Reading the Rocks*, his history of the Geological Survey of Canada, "the uses for photography doubled and redoubled":

> Besides being used to illustrate geography and geology . . . it was applied by topographers in new mapping techniques in which hundreds of overlapping pho-

tographs were taken from key reference points. Fossils, instead of being drawn laboriously by hand, were now photographed under strictly controlled conditions, and their taxonomic descriptions were augmented in this way.

Accordingly, a new photographic division was created in 1910. Professional photographers took over most expedition documentation, and full-time darkroom technicians at the Ottawa headquarters processed negatives and plates, prints, and lantern slides. After World War I, the focus of the GSC shifted from the prairies to the mineral resources of the north.

Undoubtedly the most exciting and newsworthy event in western Canada in the 19th century was the North-West Rebellion of 1885. More a series of skirmishes than a war, it nonetheless enjoyed a full panoply of charismatic characters, bloody battlefields, large-scale troop movements, an ill-advised amphibious assault, and the visually compelling contrast between the Indians and Métis and the settlers from central Canada and Britain.

Numerous photographers were drawn to the tragic events in the West. Two stand out, one for the quality of his work, the other for the fact of his being a participant in the fighting.

Captain James Peters commanded the "A" Battery of the Canadian Artillery Regiment, which saw action at Fish Creek and Batoche and trailed Big Bear north after the rebel defeat. Born in St. John, NB, Peters received his military training at Kingston and Fort Garry. He was also a keen amateur photographer who had recently purchased a twin-lens reflex camera that used the modern gelatin dry plates. As these plates were more sensitive than those that came before them, it was no longer necessary to use a tripod.

War photographs had been taken as far back as the Crimean War (1854-56), but they were invariably posed after the action. When Peters decided to take his camera on the North-West campaign, he became the first person to take war photographs during actual combat. His shots, though technically unimpressive, are of the utmost significance for western Canadian photographic history.

"The photographs I fear," he wrote in *The Canadian Militia Gazette* on 15 December 1885, "will not agree with the ordinary idea of what a battle really should look like after those striking and startling productions that appear in our illustrated journals":

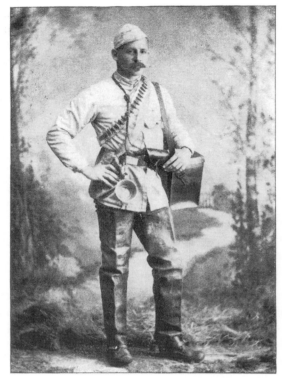

MAJOR PETERS, OF "C" BATTERY R. C. ARTILLERY, VICTORIA, B. C.

Major James Peters with his Marion Academy Camera
Victoria, BC
Photographer unknown / 1885
NATIONAL ARCHIVES OF CANADA, C–10328

I am sorry for this, but the fault is not mine. I selected the most important incidents and positions during both the actions of "Fish Creek" and "Batoche" and if they are not equal to the first-rate carnage produced from the office of the above-mentioned papers, why I must throw the entire blame on the "Marion Academy Camera" the maker of which should apologize to the public.

I carried the instrument slung on my back most of the time, and took many of the views from the saddle, for I had, in addition to the camera, a battery of artillery to look after: and the fact that 20% of my men were killed and wounded in the two engagements will be sufficient guarantee as to the indisputable fact of the plates being exposed actually in the fighting line. On

more than one occasion, the plates stood a most promising chance of being fogged by a bullet hole, but luckily such a mishap did not occur . . . Necessarily I had many failures, for out of ten dozen shots only 63 good pictures were obtained; but these proved so interesting that all my labours were amply rewarded.

The rebel marksmen, Peters complained, "did not give an amateur photographer much time with his quickest shutter," though some "were vain enough to allow me an occasional instantaneous snap." He had marked the focus on his camera for two distances: "one at twelve paces (which is needless to say for dead men). For the live rebels, I generally . . . took them from a distance, as far and as quickly as possible."

Although taken as personal keepsakes, the candidness of the images, their connection with a seminal event, and the uniqueness of what they depicted soon filtered out. The journal *Amateur Photographer* published six images in its 6 November 1885 issue. A limited offering of the photographs was subsequently made available to the public. On 18 February 1886, the *Brandon Mail* informed its readers:

The photographs taken by Captain Peters, of Quebec, during the course of the North-West rebellion, many of them taken at Fish Creek and Batoche, will shortly be issued in album form, about fifty in each. These interesting souveniers [sic] will likely be largely sought after.

Later that year they were alluded to in the prestigious *Dominion Annual Register and Review For 1885* in the section "Review of Literature, Science and Art":

Battlefield Photographs—It has fallen to the lot of Capt. James Peters, of the Canadian Artillery, to be the first to obtain photographs of battles taken actually under fire . . . Among the many noticeable exploits characterizing this short but sharp campaign, by no means the least important is the coolness displayed by Captain Peters. While bullets hissed and spluttered around and overhead, and white men were falling wounded or struck dead, this officer, with extraordinary nerve, focussed, capped, inserted the dark slide, drew out the shutter, uncapped, capped, pushed in the shutter, and put up the camera. When one thus enumerates the many and delicate operations required in the taking of a photograph, Captain Peters' exploit appears little short of the marvellous.

The other photographer deserving of note during 1885 was Oliver B. Buell, who left an extensive and excellent record of the major participants. Originally from New York City, Buell—who preferred to be called professor, though no one seemed to know what educational institution he was affiliated with—started his career in Canada as a studio portraitist in Montreal. He was then hired by the CPR to provide western scenes for advertising. Many of his images were later made into woodcuts to illustrate the railway's travel brochures. Unlike many photographers, he travelled in style. His private railway car included a studio, darkroom, kitchen, and bedroom. While he probably is chiefly known for his breathtaking Rocky Mountain scenery, his prairie photographs are arguably the most beautiful ever taken.

Buell's first photographs of the events were taken in April 1885 when he accompanied General Frederick Middleton's troops on their march from Troy (now Fort Qu'Appelle) to Batoche. He subsequently turned back, and, in a leisurely manner, secured numerous shots in the Qu'Appelle Valley of various regiments fresh off the train, and of notables in the region. He settled in Regina for July and August, in time for Louis Riel's trial. "Professor Buell last week," the *Regina Leader* reported on 6 August, "while the court was in session, succeeded in procuring six very fine pictures, which were all taken on the instantaneous system." A week later, the paper announced on page one that "Professor Buell, who has been among us for some time will soon take his departure. He is admittedly the most artistic photographer anybody here has ever seen, nor is it possible to conceive work done better."

For several years after, to offset expenses, Buell gave regular lantern slide lectures, known as "entertainments," while *en route*, some independently, others in the service of his putative employer. As the *Brandon Mail* reported on 21 May 1886:

Prof. Buell was in the city last week taking views of the place. On Monday he proceeded to Virden, and is going west from that point collecting views for the CPR. The company is no doubt going to use the collection in some large immigration scheme. The professor has a special car with a whole set of appliances, and is moved along the line as his requirements call for removal.

He was still at it two decades later when, on 26 October 1905, he returned to Regina with his "Brilliant Spectacular

Entertainment." The *Regina Leader* advertised his "luminous projections of the world's wonders presented with matchless skill":

OCEAN TO OCEAN THROUGH CANADA
across the magnificent Canadian highway from Halifax to St. John to the sunset shores of the Pacific, the Great Canadian West, British Columbia and Vancouver Island with their Towering Mountains, Grand Canyons, Bounding Streams and the incomparable scenery to be found along the line of the Canadian Pacific Railway.
PROF. BUELL WAS PRESENT
in his official capacity as Government Photographer in 1885 during the Riel Rebellion, and will present the entire series including scenes at the trial of
"RIEL AT REGINA."

Witnesses, Jury, Métis, Prisoners, Rebels, Indians, Etc. as well as 500 choicest productions of the world's wonders presented with matchless skill. Distinguished prelates, art critics and journalists have given Professor Buell's Entertainment their unqualified approval, hence it is confidently recommended to the public as a rare intellectual treat.

WESTERNERS
Up to this point, the photographing of the West had belonged mainly to photographers from central Canada, and a few Americans gone astray. Although they had an eye for an attractive scene, they lacked a basic understanding of the landscape, weather, and people. Truly accurate imaging could only come from those who lived in the region, became personally acquainted with the inhabitants, and engaged in business in the West.

The first resident photographer on the Canadian prairies was Alonzo Bernard, who established his Red River Portrait Gallery in January 1860 in Winnipeg. As the settlement was composed of farmers and buffalo hunters, Bernard agreed to take photographs—actually ambrotypes and tintypes—in exchange for "cash, wheat, flour or wood." Even those pickings were too slim; he left the colony before Christmas that year.

Joseph Langevin—cousin of Hector, the famous federal politician—established his studio in Red River in 1864. Born in Quebec around 1835, Langevin spent much of his early life in Minnesota Territory, and he was to go back and forth between there and Winnipeg constantly. He was a strong supporter of Riel and the Métis cause, and made a name for himself during the Red River Uprising of 1869-70. As the *New Nation* reported conversationally on 3 June 1870:

> Joe Langevin, the well-known and excellent artist, succeeded in obtaining a fine negative, to-day, of President Riel, in group with a number of members of the Government and prominent defenders of the people's rights. Joe, we understand, leaves by boat to-night, for Georgetown, but intends returning shortly, when copies of the above fine picture may be secured at McLaughlin's Picture Gallery.

Like other supporters of the cause, Langevin left Red River just before the Canadian army arrived in Autumn 1870. Little is known about his subsequent career, but he must have made enemies: in 1882 he was found dead in Wilmar, Minnesota, with a bullet in his head and his body in two pieces on either side of a railway track. His now-famous group portrait of Riel's provisional government was pirated by several other photographers after his demise, an all-too-common occurrence when a truly historic (or profitable) photograph shows itself.

Ryder Larsen set up his gallery in January 1867. His opening advertisement was exuberant with optimism:

PHOTOGRAPHIC VIEWS IN RUPERT'S LAND
The Undersigned Artist, begs to announce to the Public abroad that he is prepared to receive orders to furnish first class stereoscope views of scenery in this Country, the great future destiny of which will shortly make it become the [prime] attraction in British North American Territory for European emigration, its magnificent scenery and fertility of prairie and Wood lands, being unsurpassed on this continent.

He didn't last long, either. Larsen was accused of committing the first murder in the newly formed province of Manitoba in 1870, and hightailed it across the border.

Winnipeg, being the first urban centre and having the largest population of any city west of Ontario, attracted most of the photographers who came to the prairies in the 1870s and early 1880s. Professionals such as Simon Duffin (1874), Harry J. Bowles (1876), Israel Bennetto (1881), Fred Bingham (1881), John D. Hall and Skene Lowe (1883), Adam B. Thom (1884), and Thomas Colpitts (Hudson's

Bay Photo Parlour, 1884) all competed for the settlers' dollars.

As settlement radiated out from Winnipeg, photographers followed. In the 1880s and 1890s many Manitoba towns became home to photographic studios. One finds them in Emerson, Cartwright, Deloraine, Birtle, Minnedosa, Steinbach, Portage la Prairie, Morden, Carberry, Hartney, Boissevan, Rapid City, Brandon, Melita, Virden, Neepawa, and Russell. The first resident photographer in the territories that would become Saskatchewan and Alberta was George Anderton. Born in Leeds, England, in 1848, he immigrated to Canada in the early 1870s, joining the North-West Mounted Police in 1876. He was posted to Fort Walsh, headquarters of the NWMP, as well as a trading centre and Indian agency post. On his discharge in 1879, he turned his photographic hobby into a business.

Aside from a few American itinerants, Anderton was the sole photographer in the North-West Territories until the railway came through. In 1883 the NWMP abandoned Fort Walsh and moved its headquarters to Fort Macleod. Anderton relocated briefly to Medicine Hat, then to Fort Macleod in 1884.

Following the settling of Red River and its hinterlands, attention was directed toward the Saskatchewan River valley. Prince Albert, founded as a mission to the Indians in 1866, was the first sizeable settlement in the district of Saskatchewan. Fort Battleford, founded in 1875, was the home of a North-West Mounted Police post, and for several years was the territorial capital. Outlying districts included Batoche, St. Louis, and Duck Lake, a Hudson's Bay post at Fort Carlton, and a number of significant First Nations reserves, including Poundmaker, Thunderchild, Red Pheasant, and Sweetgrass. The farm land was good, the scenery was beautiful, and, most important, early surveys indicated that the CPR would likely head through the valley. Interestingly, the first issue of the first newspaper in the territory—the *Saskatchewan Herald* of 25 August 1878—reported that "J. D. Doherty and Joseph McIntyre, who have been here some time with a photographic gallery, folded their tents one day last week and moved off for Carlton, Prince Albert and all points east."

Of the first two resident photographers to practise in the valley—Joseph Carey and W. Clarke—we know next to nothing. Clarke spent time in Fort Benton, Montana, so it is safe to assume he was an American. Both are listed in directories from 1879 on. The next professional to arrive in

the region was Charles Page, first mentioned in May 1883. By November of that year he had erected a studio. While work on his building was proceeding, he took the first of many trips that he—indeed, all photographers—would make between Prince Albert and Battleford. But there was not yet enough business, for the following year Page sold his studio and became a schoolteacher. He later moved to Selkirk, MB, and resumed his photographic career.

While the CPR ultimately took the southern route, a railway eventually did come to Prince Albert in 1890. The Qu'Appelle, Long Lake, and Saskatchewan Railway branch line from Regina increased settlement and opened the way for more photographic activity. A regular visitor to both Prince Albert and Battleford was Daniel Cadzow. Originally from Auburn, New York, he spent most of the 1890s crossing the prairies photographing people and scenery. The 20 July 1894 issue of the *Saskatchewan Herald* discussed his work:

> Mr. Cadzow has just finished a lot of fine photographs that are well worthy of inspection. They embrace a variety of outside views, street scenes, groups and individual pictures, each most excellent of its kind. In outside work there is a pair of views of the Industrial School, one taking in all the buildings and the face of the hill; the other showing the main building and the pupils and staff in groups. Principal in groups is the one of Mr. and Mrs. R. G. Speers, in which that hale and hearty couple sit surrounded by their immediate family to the number of eighteen—the picture showing twenty figures, each perfectly plain and easily recognizable, even down to the smallest grandchild. Good views are also shown of the interior and exterior of the Hudson's Bay Company's store.

Although there are numerous mentions of Cadzow in Edmonton and Wetaskiwin during this decade, he exits from both history and photography in 1899 when he began to trap furs at Fort Yukon.

The photographic documentation of the Saskatchewan River Valley becomes continuous and stable with the arrival in 1896 of William James, who would operate his Prince Albert studio until 1935.

Another important prairie photographer was Cornelius J. Soule. Originally from Guelph, ON, he settled in Calgary in 1883, opening the Highland Studio. He stayed the winter, and so became that city's first photographer. As an itinerant, his most memorable prairie trip was by pad-

dle wheeler along the North and South Saskatchewan Rivers in the summer and fall of 1884. Arriving in Battleford in September, he opened a studio for a few weeks. His work was soundly praised in the *Saskatchewan Herald*:

> Mr. Soule, photographic artist, has been very busy since he came here, and besides a large number of likenesses and views for private parties he has secured a series of stereoscopic and other views of Battleford as seen from various points ... He has two admirable views of the town—one showing the main street on the north, and the other the town and hill on the south side of Battle River, besides a couple showing the town in the distance. He also has a fine series of stereoscopic views taken from the big hill to the south of the town, showing the lake at its base, and the Eagle Hills and the plains in the distance. His collection also contains a good collection of pictures of points along the railway, in the Rockies, at Edmonton, St. Albert, Fort Saskatchewan, Fort Pitt, and other points on the Saskatchewan. The views are admirably taken and should meet with a ready sale.

Soule spent the winter in Regina. He may have been at Fort Qu'Appelle at the start of the North-West Rebellion, photographing militia regiments, but in June 1885 he settled back in Regina, becoming the first resident photographer in Saskatchewan's capital. But he could not suppress his urge to travel. According to the *Regina Leader* of 23 July 1885, "Mr. Soule, photographer, has returned to Regina from Medicine Hat, where he took photographs of many of the Halifax Battalion and Otter's Rocky Mountain Rangers etc. His pictures which [we] saw at his studio opposite Dr. Cotton's are very good." Soule went on to take photographs of Edmonton and district, and eventually settled in Winnipeg.

With the completion of the Canadian Pacific Railway in 1885, the renewal of settlement, and the founding of towns along the main line, the number of resident photographers along the southern prairies expanded quickly. Following the line west, studios popped up in Moosomin, Broadview, Regina, Moose Jaw, and Maple Creek in Saskatchewan. Alberta also attracted its share of professionals in Medicine Hat, Calgary, Macleod, Lethbridge, and Pincher Creek. With the completion of the other two transcontinental railways, the Canadian Northern and the Grand Trunk Pacific, Western cities experienced another growth spurt between 1905 and 1912, and even more photographers set up shop in the cities and towns linked by the railways.

A representative photographer of the pre-war period is John Henry Gano, who documented east-central Alberta and west-central Saskatchewan. Born in 1873 in Illinois, he was an itinerant photographer until he set up a studio in Vermilion, AB, in 1904. Two years later he secured a homestead close to Wainwright, but continued to photograph from his studio in Vermilion.

In 1910 Gano was hired by the Grand Trunk Pacific Railway to document the construction of its line through Alberta. Undoubtedly he became known to the GTP through an article in the *Wainwright Star* of 9 June 1910, "The Man Who Made the Pictures":

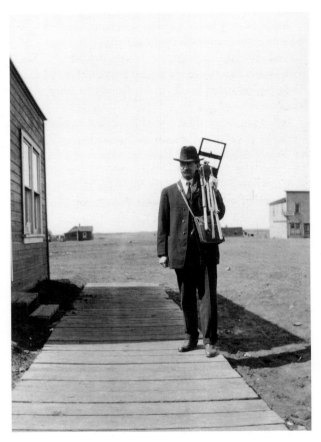

John Henry Gano with camera and tripod
Unity, SK
Photographer unknown / ca. 1925
GLENBOW ARCHIVES, NC–37–144

The thanks of the Board of Trade are due to J. H. Gano for his work . . . He is a past master in the art of outdoor photography. Wainwright being located near the Buffalo Park—which contains the largest herd of buffalo in the world—naturally attracts a large number of tourists and photographers. We have had the professional and the amateur: little photographers with big cameras, and big photographers with their famous little Kodak snap shot machines, but the fact still remains that the photographs have still to be taken that can come up to the high standards of Mr. Gano's pictures . . .

His local postcards are the wonder and admiration of every visitor. No town in Western Canada can offer such a variety of subjects. Thousands upon thousands of his postcards have been sold and mailed all over the civilized world. He is a veritable postcard king.

His postcards have also done a good work. For the country, the homesteads and the progress of the town have all been truly illustrated and chronicled in a true and novel manner. Photographs are hard facts and a good photograph speaks louder than any description could write of the country.

Gano moved his studio to Unity, SK, in 1924, but he continued to travel the prairies with a car and trailer/darkroom. He returned to Wainwright in 1931. His final years were spent in Red Deer, where he died in 1947.

The peak period for resident prairie photographers, at least in terms of numbers, was the boom of 1910 to 1914. Most of the towns and cities had been founded; the structure of the economy and prairie society was in place; there were a series of bumper crops; investment in the West was strong, especially from the United Kingdom; and there was every expectation of continued growth. The West was at the apex of regional and local boosterism, and this advertising was propelled by photography.

ALBUMS AND LECTURES

Hitherto, the dissemination of prairie photographs had been chiefly through albums and public slide lectures. Much neglected now, at one time they were both immensely popular, used by the federal and provincial governments, the railway companies, municipalities, organiza-

tions and societies, newspapers, publishers and printers, and individual photographers, among others. They were assembled to promote the advantages of regions, districts, or localities, and to be sold as souvenirs.

Initially, albums were collections of photographic prints, but production proved slow and expensive. By the 1880s, images were made into photogravure plates, and by the turn of the century into photolithography and halftones, which could be mass-produced. Until the 1950s, slide lectures meant lantern slides—large glass slides shown on a lantern projector and accompanied by a speech. Many of these series still exist. By examining them closely one can see that certain stock images

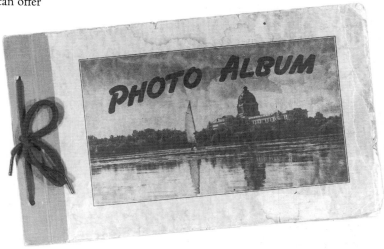

Photo album for amateurs, Saskatchewan Legislative
Building on cover
Marketed in Regina, SK / ca. 1920
B. SILVERSIDES COLLECTION

developed over the years: people, horses, or automobiles almost hidden in fields of tall wheat, swathed fields stretching to the horizon, well-clothed farm families, lines of elevators along railway tracks, well-groomed horses pulling mountainous grain wagons, bustling Main Streets and Railway Avenues, and often a nod to the disappearing "Red Man."

The local press always played a part in publicizing albums. "We have on our table," the *Brandon Daily Mail* wrote in the issue of 4 April 1883, "an elegant little book of photographic views of 'Manitoba and the Northwest' sent to us by Mr. Andrew Freeland the enterprising proprietor

of the Brandon bookstore. It contains twenty views as follows," and the writer goes on to list them:

Main Street Winnipeg, Fort Garry in 1881, Bird's eye view of Winnipeg, Manitoba college, St. John's College, City Hall and H. B. Store Winnipeg, "Outgoing Tenants" (Chippewa Indians), "Incoming Tenants" (Canadian settlers), two extended views of Portage la Prairie, view of Emerson, a general view of Brandon and views of Rosser Avenue and 6th street, the steamer Assiniboine at Brandon, Rat Portage Falls, Lake of the Woods, scene on the Saskatchewan, Selkirk, three views of different Prairie farming, Indian buffalo hunt, Freighters crossing the prairie, and the Qu'Appelle Valley.

"It is published by Campbell and Son," the story concludes, "and makes a handsome and suitable present for friends at the east."

"C. W. Mathers," the *Edmonton Bulletin* reported on 6 December 1897, "has just received his souvenir album of the Edmonton district, consisting of sixteen pages of photogravures, reproduced from photographs taken by Mr. Mathers of scenes in and around the town. There are in all twenty one views," and again he lists them, including "Indians in fancy dress and agricultural and many other scenes." The album was "gotten up in neat and first class style," and was extolled as "a most artistic and interesting souvenir of Edmonton and surrounding district."

While most of the images for such albums were produced by the local professional photographer, the town of Qu'Appelle managed to get much of the population involved in gathering pictures of the district, as reported in the local paper:

The effort of the Board of Trade to get up a pamphlet advertising Qu'Appelle and district is one that deserves the heartiest support of the residents of both town and country. Those who watch conditions here are no doubt aware that there are thousands of acres all available for settlement and at a very low price as compared with other districts. They also know that, owing to better advertising methods and a greater expenditure of money, other towns and districts no better than our own are securing a large share of immigrants.

To assist in the preparatory work and secure suitable photos for the pamphlet, *The Progress* will open

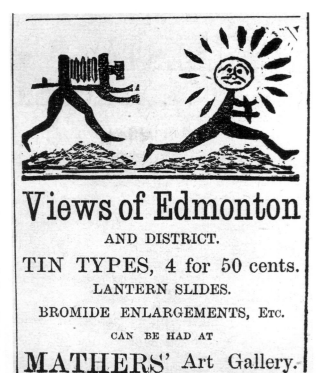

"Views of Edmonton and District"
Edmonton, AB
Advertisement for [Charles] Mathers's Art Gallery
FROM *THE BULLETIN* / 16 AUGUST 1894

a prize competition, open to amateurs. For every accepted photograph of prominent parts of this town or district a prize of 75 cents cash or one years subscription to *The Progress* will be given.

It is difficult, in these days of home theatre and video-cassettes, to imagine the popularity of lantern slide lectures. But people have always enjoyed a night out, and at the turn of the century they were curious to learn about themselves and others. They enjoyed the link to "civilization" provided by a well-prepared lecturer, who often provided a full evening's entertainment. Although travelling lecturers always "played" the larger cities in western Canada, they were probably more appreciated when they ventured into the smaller centres off the railway main lines.

Individuals and companies—much like travelling vaudeville or newsreel companies—would take a slide show on the road for several months. When it stopped

attracting viewers, they would change the topic or revamp the subject matter, add new images, and head out again. The 27 March 1888 edition of the *Regina Leader* described "a grand spectacular exhibition of photographic views along the CPR" by the Winnipeg Exhibition Company. The slide show "gave great satisfaction to the audience assembled to see the views which were excellent."

Regina was visited again the following year by "Mr. Lansdowne Palmer's Phantasmagoria Company." As the *Leader* of 8 January 1889 reported, "Views were shown on the CPR from the Atlantic to the Pacific. The mountain scenery was very fine. The entertainment will be a splendid thing . . ."

There was an audience overseas as well, as the *Edmonton Bulletin* of 18 September 1893 reported:

> Messrs. Mills and Mord, who arrived in Winnipeg last week, are attached to the British farmers' delegates by the Department of the Interior and are now on their way west. On their return east they propose making a thorough tour through the provinces of Ontario, Nova Scotia and Prince Edward Island . . . delivering illustrated lectures on Manitoba and the Northwest Territories en route. Mr. Mills visited this country three years ago and took over 1,200 views of farms and stock and natural features of the country, which he transformed into lantern transparencies for the purpose of illustrating his lectures on Canada in England and Wales. Mr. Mills' work in the Old Country is highly eulogized by the High commissioner Sir Chas. Tupper . . . also Sir John Thompson who witnessed his views and heard his lecture on the voyage . . . The success he met with through Wales and parts of England has encouraged him to make another tour.

Lantern slide lectures were widely used for disseminating information about agricultural topics. For many farmers of limited education and literacy, or lack of proficiency in English, visual aids were the only means of learning about new products, new breeds and strains, new methods and approaches to farming and stock raising.

William J. Rutherford, Dean of Agriculture at the University of Saskatchewan from 1909 to 1930, was a strong supporter of the idea of "extension"—of bringing research and knowledge out of the university and into the hands of farmers—and was quick to see the value of the lantern slide. In the university's annual report of 1918-1919, he argued:

> The value of these extension lectures in connection with rural affairs could be greatly increased by the use of more visual instruction. And for this purpose I believe the lantern slide to be of much greater value than the moving picture. Sets of slides dealing with each phase of agriculture should be prepared, and one lantern provided for the use of the lecturers on the circuit. The evening meetings at the short courses are often very largely attended, and the lantern for these meetings would prove of valuable assistance. The illustrated lecture is greatly appreciated . . .

To get to the farmers, many of whom lived in isolated settlements, all three Prairie provinces operated "Better Farming Trains," train cars fitted out to deliver educational displays and lectures. In Saskatchewan, for example, the Better Farming Train was established by the university through the Department of Agricultural Extension in 1914. Funded by the provincial Department of Agriculture, it was staffed and operated by the university. A description of the concept is found in the President's Report for 1914-1915:

> The Good Farming Trains, run in co-operation with the Department of Agriculture and the railroad companies, reached a very large number of men and women directly engaged in agriculture and there are many evidences of an awakened interest, due to this school on wheels, carrying well selected horse, cattle, sheep, swine and poultry, a car of mechanical appliances for the farm, home and barns, a car of poultry appliances, a car fitted up for teaching and demonstrating tillage and crop production, a car for home management demonstrations and a nursery car in which the children were cared for while the mothers were in attendance at the lectures. With this equipment and manned by the best instructors the College could send, the Agricultural College on wheels covered the CPR lines east and west of Saskatoon from the Alberta to the Manitoba boundaries as it had done on the lines in the south and west the year before.

The train, consisting of fourteen to seventeen cars, was divided into five sections: Livestock, Field Husbandry, Boys and Girls, Household Science, Poultry, and Farm Mechanics. Each section had a lecture/lantern car in which slide shows and motion pictures were screened. It ran for five weeks each summer from 1914 to 1922, visiting

from fifty to sixty-five communities and being seen by thirty to forty thousand people each season.

Private companies took their cue from the trains. The *Grain Growers Guide* of 29 October 1913 reported on a series of talks that appeared to have a political agenda:

> During the winter, commencing on the 29th of October, two prominent members of the Manitoba Grain Growers' Association will tour Manitoba, giving lectures at various points, illustrated by coloured lantern views. These lectures will be intensely interesting to every Western farmer who believes in freedom and the square deal, and will be descriptive of the rise and growth of the Grain Growers' Association and *The Guide*. These lecturers will also show that the many improvements which the men on the land now enjoy were secured and brought about by the farmers themselves, through their organizations, and that further improvements and reforms, which are very much needed, will be secured in the same way.

Whether public or private, the lantern slide lecture was immensely popular, and was the foremost means of combining entertainment and education until the advent of television.

AGRICULTURE

It would not be possible to overstate the importance of agriculture in the history of prairie photography. It has been the lifeblood of economic activity in the region since the 1880s. Business depended on it, politics revolved around it, everyone was tied to it and affected by it in one way or another. Photography was directly affected in two ways: first, the vast majority of the population—the customer base—were farmers who were interested in agricultural images. Second, the larger clients—government departments, grain companies, implement manufacturers and distributors—all wanted farming scenes for educational purposes, for advertising, and to document their research. A photographer who wanted to earn a living in the West had to respond accordingly, and it is not surprising that many western Canadian photographers were also working farmers. In the interests of survival, they had to acquire knowledge of the most important economic activity on the prairies.

Some photographed to supplement their income, especially during the winter. Some gave up photography to farm full time. Others abandoned farming when they realized how difficult it was. Many continued to do both, changing emphasis according to the seasons, when the crop was successful, or as time allowed. Saskatchewan, as an example, was home to at least sixty-five active photographers (who were listed as such in the various directories) who also entered or received a patent to a homestead (as documented in the homestead records in the Saskatchewan Archives).

The number of rural or small-town photographers greatly exceeded that of urban photographers, especially during the boom period and through the 1920s. Photographers were attached to towns with 500 to 1,000 residents, and, amazingly, some to towns of less than 500. There is little chance a photographer could survive in a community that size today.

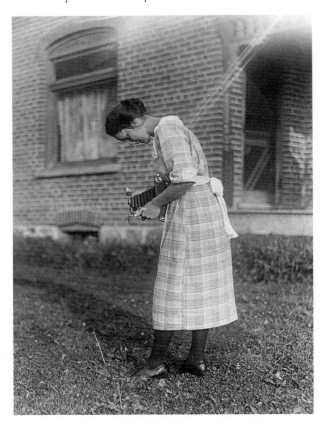

Helen Mallory Schrader photographing on her farm
Near Borden, SK
Leonora Schrader / ca. 1910
SASKATOON PUBLIC LIBRARY,
LOCAL HISTORY DEPARTMENT ,#5258

The Depression quickly and permanently thinned the ranks. The rural population was decimated within the first four years of the 1930s, leaving almost no customers. There was little agricultural research being done and no bumper crops to advertise the region. No photographer could make a living from penniless governments and corporations, and especially not from poor farming communities.

Initially, photographs were used to document settlers' farms, both as a souvenir to show the folks back home and as a means of attracting more settlers. The *Regina Leader* ran this article on 4 September 1888, under the headline "Photographing A Model Farm":

> On Wednesday a dashing team left Mr. Howson's livery stables, driving Messrs. Rigby, Hugh McKay, Thomas Barton, and N. F. Davin, M. P. away north to the Bluffs—passing on the way Messrs. Sutherland and Mr. Hunt's farms, all looking well. At the end of two hours they arrived at a beautiful cottage, hot house in front, flowers on all hands and sun flowers in great luxuriance. Seated in the parlour of the house it was hard to imagine you were in a spot which six years ago was wild. The surroundings, flower gardens, fences, all aesthetic enough to please Oscar Wild [sic]. The garden does not only grow flowers. Everything from a pumpkin to a gooseberry, from a melon to a currant, tomatoes, cabbages, turnips, radishes, celery, rhubarb, Scotch kale. It is a bit of Staffordshire beauty in the midst of the North-West ...
>
> Meanwhile Mr. Barton Jr. with three horses and a Massey reaper and binder has commenced to cut the oats and interesting it was to see the sheaves thrown deftly out. After a fragrant cigar on the shady side of the house we all went and made a group in front of stooks of oats and grainfields, garden fragrant with flowers, the yellow glory of the sunflowers shining in the bright day, and the pretty house, and were photographed. We hope the photograph will be engraved as a specimen of what a North-West farm can be.

The *Manitoba Free Press* reported on 16 June 1898:

> Some beautiful views of farm and other Manitoba scenes have been secured by photographer [Samuel] Gray for the Canadian album shortly to be published. Winnipeg is worthily represented in the collection, and the various rural scenes will forcibly illustrate the fact that prosperity waits on intelligent industry in this prairie land. The views were taken under the instructions of the local agriculture dept.

Under the headline, "Some Photos of Harvest Scenery in the District: Remarkable Pictures Said to Rank among Best Taken in Canada," the *Saskatoon Capital* of 2 November 1911 reported:

> Twenty-seven new photographs of harvest scenes in the Saskatoon district were presented at the board of trade office this morning by Mr. B. P. Skewis, who is with the Saskatoon Drug and Stationery company. Mr. Skewis has thoroughly traversed the district, hunting snapshots with all the assiduity of a huntsman hunting game.
>
> These pictures are undoubtedly the finest yet submitted and Commissioner Sclanders goes as far as to state that they are some of the best yet made in the Dominion. The Weitzen ten thousand acre farm at Rosetown perhaps furnishes the best illustrations of the whole number and copyrights of some of these have been applied for. One in particular depicts a field of wheat just being finished, with no fewer than twenty-four binders, being towed by only four engines, making the turn simultaneously at the corner of the field. The engines each pull four binders in flax and six in wheat. For scenic effect not less than for a true depiction of conditions as they are in this district, the picture is a masterpiece.
>
> Next come photos of vast tracts of level land, the crop therefrom being just threshed. The view of the prairie stretching away to the horizon in unbroken splendour is well worthy of reproduction in the board of trade or any other literature.

The various images in the series proved to have "legs," and were used in magazines, newspapers, and immigration pamphlets for almost a decade.

The farm home and family were also a major focus of photographers. In *Crocus and Meadowlark Country* (1963), G. Thomson describes how the taking of a family portrait was a special occasion, and incidentally gives some insight into the character of the photographer:

> While we were eating our dinner Father told us he had seen Ed Auclair and he was coming to take a photograph of the farm buildings and all of us. Edmond Auclair was a Frenchman who lived on a homestead about two miles south-east of us. He had been given

the nickname of "Professor" because of his pedantic way of talking . . . The professor lived by himself in a little shack . . . the walls were covered with flowered wallpaper and decorated with pictures of stage beauties clipped from San Francisco papers, as that was the place from which he had come . . . Over the door he had printed a sign "Sunny Slope Farm" and below this "Edmond Auclair—Photographer" for he eked out a scanty living by taking photographs of any homesteaders who could afford to pay.

There follows an account of the picture-taking session:

When we found he was coming to take pictures, Chaddy and I were quite excited. This was before we had such things as snapshots, and having your pictures taken was quite an event. We kept looking across the prairie to see if he were coming, and soon saw his lanky figure striding along the trail, with his coat-tails flapping behind him. Then the whole farm went into a state of action, for in those old time photographs every person and every animal had to be seen. We had to bring the cows in so that they would be in the picture. Winnie and Ethel, our two sisters still back in Galt, Aunt Mary and all the other relatives there simply had to see what Annie Rooney looked like. Buck and Queen were turned loose inside the yard and given oats on the ground to keep them quiet. Jim saddled and mounted Dixie and posed in the foreground complete with sombrero and rope. The rest of the family grouped themselves in front of the house according to directions from the professor as he emerged from time to time from under the dark cloth of his camera on its tripod . . .

All was now in readiness, even to the new kitten playing beside the front step. Then Buckles got impatient for a run with Dixie and began to jump up and down excitedly. "Sit down" Jim shouted, and Buckles obediently squatted down with his back to the camera just at the moment the picture was taken.

A few days later the professor brought over the finished photograph and we all gathered eagerly around to have a look at it. There was the house looking plain and unadorned, the stable, and the other little building which was sure to appear in all the pictures we took. There was Buckles with his back to the camera, Dixie with arched neck and Jim proudly in the saddle, while Bee reclined gracefully on the front doorstep. Father

posed as the landed proprietor, with Mother nearby. Chaddy stood rather belligerently in the foreground, and while I looked as broad as I was long, no one would have noticed that my eyes were swollen.

Much can be read into a farm family photograph—how the family lived, what was important to them, how they wanted to be seen. The farm photograph became a treasured heirloom in the tradition of the family Bible, and was passed down through the generations.

Much of the visual history of prairie farming has been kept in what are now labelled stock libraries. Some were operated by the federal and provincial governments, others by private corporations such as the railways and implement manufacturers, farming journals, grain companies, and, after 1939, the Stills Division of the National Film Board. These libraries incorporated the work of many photographers, often a combination of contracted professionals and staff photographers. Corporate photographers used to make periodic sweeps through the prairie to update and add to the stock of images. As the *Edmonton Bulletin* reported on 15 September 1892, "Messrs. Henderson and Clark, photographers for the CPR visited Edmonton on Monday's train and were driven around on Tuesday by W. Wilkie, of South Edmonton. They took views of both sides of the river, at Edmonton, Jas. Price's farm in Belmont, and the Clover Bar ferry crossing. They left on Wednesday's train."

Similarly, on 26 June 1899, the *Bulletin* announced that "J. Wilson came in on Friday's train. Mr. Wilson is an old country photographer and is employed by the Dominion government and the CPR to collect photographs of Western Canada, which are to be distributed throughout England, to assist immigration."

The Saskatoon *Star-Phoenix* carried this story in its 17 September 1919 issue:

Two photographers of the Publicity Department Canadian National Railways arrived in Saskatoon last evening from Winnipeg on tour of the West to secure fresh stocks of photos for the company's coloured views and publicity work. They will remain in Saskatoon today, seizing all chances of good scenery that may present itself after which they continue their journey west. Ernest Blow, formerly of the Winnipeg Free Press staff, and Witt Robinson, also of Winnipeg,

are the two men, and will take advantage of the visit of the Duke of Devonshire today.

Another interesting and little-known stock of prairie photographs are the collections created and accumulated by the photographic departments of the three provincial governments. Alongside the expected shots of dignitaries and events, government photographers shot some truly unique material, usually in small towns or rural areas; it is unique in that it would never have been shot by a commercial photographer who could not have made money from it.

The Alberta Department of Economic Affairs, for example, founded a Photographic Branch of the Publicity and Promotion Office in 1946. Based in Edmonton, it acquired the services of staff photographers Fred Amess (d. 1946) and then Melvin Petley-Jones, from the Travel Bureau. Its mandate, stated after a full year in operation, was, first, to induce "larger numbers of visitors to come to Alberta and remain here for longer periods," and "to encourage and direct interest about Alberta in a way that will lead to the development of the province's natural resources. Another function is to serve all government departments so as to bring essential information to the attention of the general public." The branch's first project was the production of *Your Opportunities in Alberta*, a booklet issued in 1947 and reprinted and updated for many years afterward.

In 1949, the branch became a fully functional and autonomous work unit with the appointment of Ken Hutchinson as director and with the hiring of two photographers, C. R. (Chuck) Ross, a bright light of the Canadian Army Film and Photo Unit and at the time working for the *Edmonton Bulletin*, and Larry Matanski, later to be the earliest feature film producer in the province. "In the past eighteen months," Hutchinson wrote in the annual report that year, "the change has been completed from the time when the government was largely dependent for publicity pictures upon outside photographers to the point where it is now entirely self-sufficient in both still and motion picture work."

This was the start of the second great expansion in provincial advertising. Alberta, favoured by mountain scenery and the lure of oil, was leagues ahead of its neighbours. Throughout the 1950s, images from the Film and Photo Branch were published around the country and, indeed, around the world in such places as *Time*, the *New York Times*, *London Illustrated*, the *London Times*, the London *Daily Mirror*, the *Globe Encyclopedia*, and too many Canadian newspapers to mention.

By 1952, the mandate of the Branch had been clarified as "the production of illustrative material, both still and motion picture, for the general information of Albertans, Canadians, and interested people in other parts of the world on such subjects as our land and its resources, our social and economic conditions, and our way of life in general."

This was carried out through the production of black-and-white images (the major activity of the Branch), colour images (usually as transparencies for the new photographic magazines that preferred to print from a positive), and printing and hand-colouring enlargements of Alberta scenes to hang in politicians' and government offices as well as embassies, consulates, banks, railway stations, and other public buildings. By this point, the staff photographers numbered five, with the addition of Ed Matanski, William Ely-Round, and Bill Marsden.

The big year for the Film and Photo Branch was 1955, the province's Jubilee year. The Edmonton office remained busy documenting the celebrations and ceremonies of rural towns. They added another photographer, Bruno Engler from Banff (another alumnus who would go on to a successful career in film-making), while Bill Marsden opened an office and darkroom in Calgary to cover burgeoning southern Alberta. "The move has resulted in a saving of both time and money," the annual report confirmed, "and the fact that a government photographer is now resident in our second largest city is appreciated by all Departments."

The Branch produced 16,023 black-and-white prints that year and 500 colour transparencies. The following year they gathered the finest 250 images taken during the Jubilee year and produced *The Jubilee Photographic Album*. Following 1955, black-and-white photography started to decline, while colour work and motion pictures took off.

Hutchinson died in 1968 and was replaced as director by Chuck Ross, who went on to become Alberta's first Film Commissioner. The Film and Photo Branch ceased to be a separate unit in 1972. Its staff was absorbed into the new Public Affairs Bureau, its duties privatized in the late 1980s.

The Saskatchewan and Manitoba photographic branches followed similar paths. But they all produced extraordinary work—not the bland, bureaucratic images

one might expect from a government agency. Most of the photographers came from the private sector, and many would return to it. They were hired at the peak of their professions, and many played critical roles in the formation of professional photographic associations in their respective provinces. Many went on to write about and teach photography and introduce a new generation to the art.

AMATEURS

The amateur photographer has always played a large, and largely unappreciated, role in documenting prairie life. In some ways, amateur images have given us a more authentic vision, as professionals tend to idealize or show the most attractive view of any subject in the interests of making money. The amateur snap-shooter, on the other hand, records events, ceremonies, people, vacations, and scenes that are personally meaningful in a straightforward, unpolished manner. The technical quality of the amateur photograph is generally inferior, but there can be no doubt as to its historical importance.

The amateur is someone who takes photographs for the love of it. "There is nothing at present which gives more intelligent recreation than a Kodak or camera," according to Winnipeg's *Town Topics*; "one has only to use either a very few times to become fascinated and that fascination will soon develop into what is commonly known as a 'Kodak Fiend.' In Winnipeg we have our full share . . ."

Two technical advances fuelled the growing popularity of amateur photography in the West, particularly in rural areas. The first was the invention in 1888 by George Eastman of plastic film, both sheet and roll, which allowed the taking of a large quantity of pictures in all temperatures with no set time before they had to be processed. It was light in comparison with glass plates, so one could go into the country without having to take a wagon.

The second advance was Velox photographic paper, invented by Leo Baekeland in 1892 and marketed by Eastman Kodak. It was sufficiently sensitive that it did not require the action of sunlight; it could be exposed by electric light, meaning one could make prints in any season and at any time of day. Shunned by professionals, it was welcomed warmly both by amateurs and by a newcomer to the photographic community: the photo finisher, who could now quickly turn out large quantities of other people's prints.

On the prairies, amateur photographers came from every walk of life: real estate agents, bureaucrats, doctors, lawyers, university professors, travelling salesmen, clergy-

"Kodak Harvest Time"
Edmonton, AB
ADVERTISEMENT FROM *SATURDAY NEWS* / 3 SEPTEMBER 1910

men, North-West Mounted Policemen, architects, home-makers and, of course, farmers. For ease of description, they can be divided into two categories: urban amateurs who had access to equipment and supplies—and one another—and rural amateurs who followed their hobby in relative isolation with their basic cameras and developing outfits.

As professional photographers came together as a result of common interest, so, too, amateurs would make one another's acquaintance in a community and meet to share their knowledge and enthusiasm. Their aims were to teach one another, display their work, offer and receive criticism, promote the ideas of art photography, go on group expeditions to scenic areas, perhaps share the cost of supplies, a piece of photographic equipment or a darkroom, and socialize.

The first known amateur organization on the Canadian prairies was the Winnipeg Camera Club, formed in the spring in 1898 when ten enthusiasts felt "that it was the proper time for the starting of a camera club." History records that "a meeting was called for the 26 of May 1898, at which Mr. R. J. Campbell was elected president, and by-laws were adopted."

The Winnipeg Camera Club was responsible for organizing the first exclusively photographic exhibition held in western Canada. It was assembled in the club's rooms in the McIntyre Block in October 1901 and open to the public. Owing partly to the novelty of the medium and partly to the appeal of the local subject matter, it was an event of impressive proportions. It was thoughtfully reviewed by the *Manitoba Free Press* on 3 October, under the headline "Artistic Creations of the Camera":

> During the day and evening there was a large attendance of those interested in photography, while the numbers of those who registered showed that the interest in the exhibition was not confined merely to citizens, but extended also to the visitors in the city. Now that the sterling quality of the work done by the members of the club is known, there is certain to be a considerable increase in attendance during the remainder of this week. Few amateur exhibitions held anywhere in Canada can show a wider display of work ...

The reviewer commented on the merits of each entrant, including one Jno. A. Echlin, whose "two pictures on the Lake of the Woods are very strong and original, both in subject and treatment, being full of contrast of light and shade, both in sky and water . . . Mr. Echlin has also attempted two studies in the nude, one of which 'Despair' is a strong and effective picture . . ." To a Mrs. Fry, however, belonged the honour "of exhibiting the best portrait in the collection. Her two studies are easy in pose and natural in expression, and the lighting is skilfully handled. The negatives are soft in quality, and the prints are of fine texture. The pose of the girl in the mantilla is especially good . . ."

The reviewer continued, demonstrating a wide-ranging knowledge of composition and an obvious sympathy for the medium:

> Mr. J. G. Norris has a number of excellent prints, his best undoubtedly being that of a hayfield which has a fine atmosphere quality, as well as being remarkable for its depth of definition . . .
>
> Alderman Fry exhibits a foreshortened portrait of a lady in which the face contours are ill-defined through poor lighting. His snap of two cyclists passing through a gate is, however a most creditable picture, as is also his Indian mounted on a cayuse . . .
>
> One of the noticeable features of the exhibition is the collection shown by Rev. Mr. Cameron, the president of the Brandon camera club. These secured first prize at both the Winnipeg and Brandon exhibitions. They include figure, architecture and landscape . . .
>
> One of the most beautiful miniatures in the exhibition is Mr. H. M. Marsden's "Early Morn." Though but a 2 x 4 print, it has individuality and artistic distinction. The same exhibitor's "The Homeward Way"—a study of cattle, foliage and shadow—is also a very fine specimen of a platino print. Mr. H. A. Wise shows only one print, an effective picture of a Red River cart. Mrs. Fry's view of Selkirk from the river is one of the most admired landscapes in the collection.

There is little doubt that this show helped raise the visibility of photography in the West, and showed that the creation and appreciation of interesting photographs was possible for anybody.

The Winnipeg Camera Club continued to grow, and served as a model for other associations on the prairies. Over the next few decades, camera clubs were formed in Brandon, Regina, Saskatoon, Edmonton, and Calgary, bringing amateur photographers together and raising the level of the art and technical skill across the West. By the 1940s numerous "salons," or exhibitions, incorporating work

from club members across Canada, were being staged annually throughout the region.

There have been a number of extremely talented amateurs active on the prairies—some recognized in their time, others just being discovered today. One of the most notable was Dr. Leslie G. Saunders. Born in 1895 in London of a photographer/architect father, he received his university training at Cambridge and became a well-respected biologist. He immigrated to Nova Scotia in 1910. Fifteen years later he was offered a teaching post at the University of Saskatchewan in Saskatoon, where he was to remain for thirty-six years.

A gifted amateur artist, Saunders mastered many media, but it was photography that brought him the most success and satisfaction. As early as 1928 he was exhibiting his work with the Royal Photographic Society; within a decade had become an associate member. Not surprisingly, he was also one of the most respected members of the Saskatoon Camera Club, and his work was entered in most of the major North American salons throughout the 1940s and 1950s.

Saunders did all types of photography, from travel to tabletop to portraiture, but his most popular work was his prairie landscapes: haystacks, farmyards, meandering trails, fields of crocuses. His pictorialist approach—using soft focus, altered negatives, and textured printing papers—was a trend in camera club photography from the 1920s on, and Saunders's was particularly interesting. He died in 1968.

Lone photographers out on the land were not a part of the wider photographic community. Because of this, they were more self-motivated and less reliant on the praise of their peers than city practitioners. Most small towns and districts boasted at least one casual photographer. Many of these unsung amateurs are known to posterity solely as a passing mention in a local newspaper. The *Regina Leader* reported on 17 July 1888:

On Wednesday a picnic was given at Buffalo Lake, near Mr. Nicholle's. A large number of people drove from town and enjoyed themselves immensely. Base-ball, racing, etc., helped to pass the time enjoyably for a few, while others strolled among the trees and bushes. The spot is a lovely one for a picnic, being situated at the foot of Buffalo Lake, not far from where the Moose Jaw river empties itself into the Qu'Appelle . . . Altogether the picnic was one of the

most enjoyable ever given, and the Lake people who took the trouble to arrange it deserve the hardy thanks of everybody. Mr. Knowles, Presbyterian Missionary at the Lake, presided, and Messrs. J. H. Ross, M. L. A., and G. M. Annable addressed the people assembled. Mr. Charles Gass also took photographic views, which promise to be a great success.

More appreciative of such amateur efforts was a story that appeared in the 16 February 1900 issue of the *Edmonton Bulletin*:

E. J. Lawrence, of Vermilion, Peace river, has a number of most interesting photographs of his home on Peace river, harvesting operations, field of growing oats, ice leaving the Peace, view of his saw mill destroyed by fire, snap shot of the treaty commissioners taken last summer, as well as numbers of other scenes along the Peace. Though taken by an amateur the work is well done. The great interest however, which attaches to the views is that they show as nothing else would what the Peace river country is and what it can do in the way of agriculture and other industries.

Almost any event was worthy of an amateur's attention. As the *Hanley Herald* observed on 27 October 1905, "Twelve loads of wheat arrived at the Crown Elevator on Tuesday last, and our local photographer took a snap shot as they were awaiting their turn."

And on 23 November 1906:

An enjoyable evening was spent at the house of Mr. and Mrs. Wm. Duncan last Friday, the 9th inst., the occasion being a farewell to Mr. Lloyd Duncan and Miss Kate Rowe, friends of the host, who have been staying with them for a few weeks and who are again returning to their home in Ontario. Although the night was bleak quite a number were present and the good cheer within and kindly welcome of the hostess soon made them forget about the chill without . . . By nine o'clock all the guests had gathered and for the next two hours joined enthusiastically in the games. An interesting feature of the evening then came in the form of a taffy pull. When this was over the party arranged themselves to have their picture taken. Mr. Blue who had brought his camera was photographer. Just at the critical moment some were not in the best order to be taken and the shy bachelors and coy maidens are anxious to see what they look like, so we hope

Mr. Blue will not keep them in suspense any longer than is necessary.

For most rural photographers, existence revolved around their farms and the many activities needed to keep them operating. Fortunately, amateur photography could fit right in. Most farmers were introduced to the craft by advertisements in the various farming newspapers and journals. The *Grain Growers Guide*, for instance, ran this ad for several months in 1912:

> There's a profit side as well as a pleasure side in the use of a Kodak on the farm: pictures of stock that you have to sell, pictures showing the development of animals at a certain age, of crops at a certain stage of growth, of buildings, and of ditches and fences and roads—all these can be used to advantage in systematizing and making your farm profitable. Pictures of your family and friends, pictures of the places you visit and the things you and your family are interested in—these will add to the pleasures of home life for all the household.
>
> And **you** can make such pictures.

While the horse, cow, dog, and cat were the farm animals most likely to find a place in the family album, sometimes even the pests were considered worth capturing. The *Medicine Hat Times* of 7 September 1888 felt this story was worthy of their readers:

> In J. K. Drinnan's window there has been exhibited for the past few days by W. B. Fleming a photograph of a bunch of rattlesnakes. The picture was taken on Saturday afternoon—a snap shot—by C. C. Cochrane. It shows a regular tangle of snakes, three or four dozen, all sizes, bunched up into a small [compass] and basking in the hot sunshine on a prairie hillside . . . it would be a good location to bury a stick of dynamite with a fuse attached . . .

One of the most enjoyable activities of the prairie year for the farmer was the annual agricultural exhibition held in most towns and cities. Here was prime subject matter for the snap-shooter, as R. C. Gardner noted in *Amateur Photographer*, August 1934:

> An agricultural show offers the amateur photographer a unique opportunity of trying out almost every branch of the art, from landscape to interior, from portraiture to high speed work, all within the compass of a couple of days and a few acres of space . . .
>
> As to the opportunities offered, not only to secure "memory" pictures, but also pictures which may quite possibly be saleable. The newspapers seem to have a partiality for photographs of pigs, especially if the pigs be doing something unusual, such as leaping from their sty, or eluding capture by discomfited humans. The day before the show opens is the time to get the best pig photographs. By wandering round the stockyard in the evening, you can see pigs of all kinds and sizes—fat sows, huge tusky boars, small piglets—being scrubbed, combed and generally groomed to make them fit to enter the judging ring the next morning. The sight of a freshly lathered boar, breaking away from the helpless "barber" whom it has probably knocked over, is too good not to risk a shot on . . .
>
> Then, early on the morning of the first day comes the judging of all kinds of stock, and you can get bulls, cows, goats, sheep and pigs, either singly or in procession to and from the judging rings. Later in the morning the judging of hunters and polo ponies in the large ring gives ample opportunity for action photographs of horses, and further opportunity for this high-speed work will come with the jumping competitions . . . and the musical rides, jumping displays and trick riding by cavalry or mounted police must not be forgotten.

The agricultural exhibitions also provided a venue for displaying amateur photography. Almost all fairs had a section where people presented their artwork and crafts. Photography was usually included with the other graphic arts. Occasionally there would be reviews of the exhibits, or prize lists, in the local paper. The Territorial Exhibition of 1895 in Regina had an unusually large section devoted to the arts. As the editor of the *Leader* noted, "the exhibits of photographs, water colours and oil paintings are very fine indeed, and are evidence that art is having an unusually early place in the attention of the inhabitants of the young western province and territories."

For many rural amateurs, magazines were their only connection with the wider world of photography. Journals popular in the country included *Canadian Photographic Journal* (1892-1897), *Canadian Kodakery* (1914-1932), *Canadian Photonews* (1954-1956), *Canadian Photographer* (1954-1963), and *PhotoAge* (1954-1967). But the longest-lasting—and arguably the most helpful—photographic column was published in *Farm and Ranch Review* from 1958

to 1966. "Photo Corner" was intended for amateurs, and over the years it touched on every conceivable topic of interest to the farm-based enthusiast. In the inaugural column, the writer put forward the idea that this was "a picture-taking age":

> More and more people are getting the camera habit, whether with simple box cameras or the most technical and expensive equipment. Judging by the number of photos submitted by our readers, the interest in this hobby must be widespread across the prairies. Therefore, starting next month, the *Farm and Ranch Review* will begin a series of articles on photography especially prepared for our rural readers. Photography is a wonderful and rewarding hobby for country people. Writers tell us that the best stories relate to the simple things with which we are familiar—not the dramatic scenes in the exotic settings of far-off places. The same is true of pictures. Good pictures are everywhere about the farm and ranch; in our loved ones; our children happy at play; our homes and day-to-day tasks; the people we know and the beautiful countryside in which we live . . .
>
> Picture possibilities are infinite, and since it is as easy to take good pictures as bad, we hope that we can pass on some valuable tips to readers who are after better pictures . . .

The subtitles of a few instalments give a good idea of the range: "Facts or 'Fish Stories'. . . Prove it with Pictures," "Pets Make good Subjects," "Subjects Should be Natural," "Photographing Animals," "Focus . . . on Autumn Scenery," "Kids are Fun to Photograph in Any Mood," "Photo Greeting Cards Are Truly Personal," "Winter Offers Many Scenes," "Develop your Own—It's Easy," "Teach a Child How to Use its Camera," and "Hunting—With a Camera."

AERIAL PHOTOGRAPHY

The most underused and undervalued application of photography in western Canada is undoubtedly aerial photography. Aerial photographs of the prairie landscape continue to be a goldmine of information and documentation—and can, incidentally, be both fascinating and aesthetically pleasing. There is a visual appeal to the aerial photograph found nowhere else in the medium. Arnold Sandwell's "The Camera Takes to the Air," in the May 1930 issue of *Canadian Geographical Journal*, shows the enthusiasm with which aerial photography was first greeted:

> Anyone who has ever carried passengers for their "Baptism of the Air" . . . cannot fail to have been struck by the reiteration of one remark by newly-landed patrons. "I could see the whole country spread out below me just like a map!" They might well go further! No map gives the full effect of an aerial view. The occupant of an aeroplane sees something "just like a map" but it is a living map, with its puffing toy trains, its moving boats and autos on river and road, its smoking chimneys and animated inhabitants, all the manifestations of action that are so notably absent from a printed map.

The genesis of aerial photography in Canada had a practical basis: to assist in the production of army maps. The earliest airborne photographers worked for Canada's armed forces during the Great War, when an accurate knowledge of enemy troop movements, trenches, and artillery could decide the outcome of a battle. Both types of aerial photography were common during the war: the oblique image (the camera pointed to the horizon, thus showing perspective) and the vertical image (the camera aimed straight down to the earth's surface). The photo mosaic—the overlapping of a continuous band of photographs—was used to chart wider areas. By 1917 aerial photography was being taught to recruits at Camps Borden, Desoronto, and North Toronto.

The Canadian government was delighted by the usefulness of aerial photography: its resolution, the bird's-eye viewpoint, and the fact that a permanent and updateable record could be kept of almost any landscape or event. In 1920, accordingly, the Air Board of Canada was established within the Department of the Interior. Air bases for the purpose were established at Victoria Beach on Lake Winnipeg, and at High River, south of Calgary. In 1922, the Air Board merged with the RCAF (then just the CAF), and three years later established the National Air Photo Library in Ottawa.

Peacetime applications for aerial photography developed quickly. It speeded up and made easier the mapping of any region. It could document erosion, hail and flood damage, soil conditions, the accretion of alkali in flats, the progress of settlement and cultivation, crop conditions (including the spread of plant diseases and pests), and surveys of animal herds and migration patterns. It was used to determine the suitability of areas for new settlement, the

William J. Oliver (with camera) and pilot from
Great Western Airways Ltd.
Calgary, AB
Photographer unknown / ca. 1924
GLENBOW ARCHIVES, NA–4868–44

water-carrying capacity of river valleys, the location of gravel pits for construction, and logical routes for railways and highways. Finally, it allowed the documentation of human intervention in the landscape: the irrigation canals in southern Alberta, for instance, the Gardiner Dam on the South Saskatchewan River, and the Red River Floodway.

Although the major clients of the photo libraries were governments, there were many other types of customers as well. Western oil companies, especially after the Leduc finds of 1947, started to spend huge amounts on photo documentation. Map and atlas publishers, prospectors, surveying companies, and magazines and newspapers were all willing customers.

An early, prescient article entitled "Sky Views" was pub-

lished in the 23 August 1919 issue of the Banff *Crag and Canyon:*

Photography has made a definite advance, in its commercial application, since the termination of the war and the raising of the ban on aeroplane flights over Canadian cities for civilian purposes. The latest step in the photographic field, as linked with aerial "navigation" has been the development of a business to take pictures of municipalities, manufacturing plants, farms and various areas. No longer is it necessary for a corporation manager to engage a pen and ink artist to sketch a bird's eye view of a factory. The executive now merely phones to the aerodrome for the aerial photographer and the factory plant is "shot" from several dif-

ferent angles with the photographic gun. The desired picture is then used for letterheads, catalogues and other printed matter. The real estate man wants a sky-high view of a subdivision, oil field, or farm property and the aerial voyageurs do the trick. The vain profiteer is tickled with the thought of possessing a handsome photograph or moving pictures of his palatial residence on the hill as taken from an aeroplane and he gives an order for the pictures.

Two important RCAF aerial missions were flown in the summer of 1922. The first was along the Saskatchewan, Clearwater, and Red Deer Rivers, the second along the Highwood and Oldman Rivers up to Pincher Creek. These images were used by the federal Reclamation Service to locate suitable irrigation canals. In 1923 the Cooking Lake area east of Edmonton was photographed from the air, while the focus of 1924 was the Edmonton, Vermilion, and Wainwright districts and west to the eastern slope of the Rocky Mountains. The true purpose of these flights remained a mystery to many people, and a number of illegal stills were hastily dismantled in the foothills, their operators convinced that the overhead flights were inaugurated expressly to search them out.

Prairie aerial photography really found its niche starting in 1935 when the federal government established the Prairie Farm Rehabilitation Administration. Headquartered in Regina, it was formed to assist farmers in all three Prairie provinces who had been devastated by drought, outdated farming techniques, and soil erosion. Its efforts were initially directed toward locating, protecting, and diverting valuable water resources. Photographic surveys were used to chart the subtle contours of the region, trace the progress of shifting soil, and determine which types of vegetation were hardy enough to live through the trying weather conditions. A combination of RCAF, PFRA, and contracted independent photographers provided the PFRA with the information it needed to construct the Bow River Irrigation Canal, the St. Mary's River Irrigation Project, and the Gardiner Dam.

In 1927, a land classification project was jointly initiated by the Federal Department of Agriculture and the three Prairie provincial universities. Initial surface surveys proved to be slow, so the crop scientists took to the air. Millions of acres were photographed and re-photographed so that a decline or recovery in the quality of the land could be demonstrated. As D. Thomson reported in *Skyview*

Canada: A Story of Aerial Photography in Canada:

Vertical aerial photographs were taken at a height of about 8,000 feet above the land surface at a scale of 1: 15,840. These photographs proved most valuable in mapping the land, including the accurate locating and measuring of sloughs, ravines, eroded areas, cultivated acreages and farmsteads. For example a selection was made of 86 townships in southwestern Saskatchewan and the area was flown photographically in 1938, 1949 and 1955. The flying was performed by the federal government or by commercial agencies under contract to it. All photographs were taken concurrently during the crop-growing period and were processed by the Department of Agriculture. These were taken especially for the department's Economics Branch and for the PFRA. The 1955 photographs were particularly clear and highly useful in identifying the patterns made in the fields by various types of farm machinery. The 1938 photos, however, left a great deal to be desired. This is hardly surprising in view of the improvements since the 1930s in chemicals, photographic papers, cameras, lenses, filters and aircraft. Nevertheless, comparisons of the periodic photography over a specific area revealed much enlightening and valuable information.

In 1950 the RCAF undertook extensive photographic coverage of the Red River flood damage. To get a continuous picture of the entire length of the river, they compiled a giant aerial mosaic ten feet high and fifty feet long. It was so impressive that it was displayed in the House of Commons, and the information from the massive image was invaluable to the planners of the Red River Floodway.

Private-sector aerial photography co-existed with government activities from the beginning. When the RCAF was unable to keep up with demand, provincial and municipal governments turned to private operators. Many companies consisted simply of pilots who learned how to handle a camera; others were commercial photographers who contracted with local pilots to get them airborne; still others were surveyors or even crop-dusters who added photography to their services.

Private aerial photographers found many means of marketing their images. One that was guaranteed to appeal to rural customers was low-level, oblique views of individual farms and ranches. "Photographing farms and ranches was the big scam then," recalls Bill Marsden, a Calgary photographer in the 1950s—"most of those operators were

salesmen and promoters rather than photographers, but if the weather was good it wasn't that hard to get a fairly good picture. I remember the whole idea was to get as much money out of the farmer as possible!" It is still not uncommon to see a hand-coloured, framed aerial view of the home quarter hanging in the farm kitchen or on the living room wall. Low-level views of towns, industries, and geographical sites made ideal images for postcards, calendars, and place mats as well.

From the 1920s to the 1940s, one of the biggest national players in the field was Canadian Airways Ltd. Founded by James Richardson of Winnipeg in 1920, it was more a conglomerate than a unified company. It merged with or took over Interprovincial Airways (which itself took over Fairchild Aerial Surveys of Canada), International Airways (not as international as it sounds) and, most importantly for the prairies, Western Canada Airways Ltd., which had offices in both Winnipeg and Edmonton. This group, which had for all intents and purposes formed a monopoly in private-sector aerial photography, was absorbed by Canadian Pacific Airways in 1942.

Aerial photographic companies operating in the three Prairie provinces in the post-World War II period included Ranson Photographers in Edmonton, McPhail Airways in North Battleford, and Range Aerial Survey Ltd. in Calgary.

A QUESTION

Are prairie photographs different or unique? Yes, especially rural scenes. One reason is the unique subject matter, subjects that could only be found on the prairies: flora and fauna such as lilies, cacti, and buffalo, geographical features such as alkali flats and coulees, tipis and sod huts, grain elevators, shelter belts and dugouts, not to mention the original peoples: Cree, Blackfoot, Assiniboine, Dakota, Saulteaux, Sarcee, Métis. The immigrants and settlers were people without pretensions. The majority were dry farmers and had no problem being shown with or associated with their everyday activities.

Another reason is the simplicity of the landscape: a flat or gently rolling foreground surmounted by an immense arch of sky. The concept of flatness is intriguing for its apparent limitations and the challenges it poses for the photographer. Prairie images contain straight lines, gentle contours, angular wheat fields, small towns; above all, they exhibit a quality not generally seen in mountain and

maritime images, or even the Canadian Shield: subtlety.

Then there is the quality of light. In contrast to the landscape, it is anything but subtle. It illuminates everything, hides nothing. In his 1890 article, "The Great Plains of Canada," C. A. Kenaston tried to explain its extraordinary clarity:

Perhaps the first thing which will impress [a traveller] will be the absence of what Mr. John Burroughs calls an atmosphere. For the first time in his life he will feel that he is out of doors, or that his eyes have been suddenly opened. Objects which under other circumstances would have tempered and softened outlines, or would be altogether invisible, now seem as sharply defined as the shadows of houses or trees in the glare of the electric light. There is no toning of the light, and between the blades of grass on the ridge of some slope many rods away from him, he sees with utmost distinctness to unimaginable distances . . .

Captain Henry St. Clair Street, head of the First Alaskan Air Expedition, flew over the Canadian prairies in July 1920. He was so taken by the light that he commented on it numerous times in his 1922 written account. "Ten minutes of flying through clouds brought us suddenly out into a beautiful clear sky," he wrote. "For the first time we feasted our eyes upon the famous clear landscapes of the West. From our altitude of 5000 feet we could see the horizon, 40 or 50 miles away, all around us. Never had I flown through an atmosphere so pure and clean."

And again:

If readers of The [National] Geographic will turn to their maps of Saskatchewan, they will find portrayed a wide, smooth country, fairly dotted with small towns and villages. If they had been with us on the morning of July 26 . . . flying through a sky of surpassing loveliness, the air so clear that it tingled, the flat farms spread out beneath them with extraordinary distinctiveness as far as the eye could reach, they would have believed readily enough that the entire map of the district was spread before their eyes. The atmosphere is so astonishingly clear and the view so extensive that it becomes confusing to follow a set course, because of the beautiful sameness of the scenery.

The quality of the light was the subject of a brief editorial in The Beaver magazine, which made a logical (if far-fetched) prediction in its June 1921 issue:

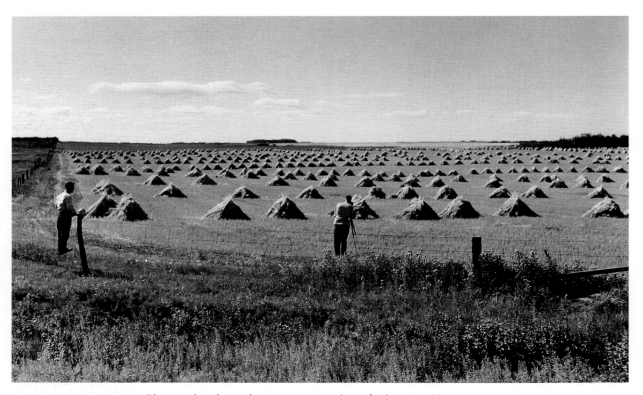

Photographing haystacks on prairie—members of Labour Day Photo Group
Saskatoon district, SK
Thomas Melville-Ness / ca. 1946
SASKATCHEWAN ARCHIVES BOARD, S–MN–B672

Motion picture studios cluster on the southern California coast, for one reason—because producers found there "more and better light."

We wonder if any of these producers or their cameramen ever realized that the atmosphere of Western Canada Prairies—considered photographically—would make the world's brightest films.

Some day, some motion picture magnate is going to glimpse, say, Winnipeg from a high window of the Fort Garry on a glorious spring day right after a rain has given the air an extra cleansing and see buildings, trees, and people so marvellously focussed—so sharply etched in super-lucid perspective—that he will start a string of studios at "Red River."

Prairie sunsets are legendary for their scale, dramatic colours, and duration. "No sight in the world possesses greater grandeur than a sunset on the Canadian Prairies,"

according to a 1924 pamphlet entitled *Saskatchewan— Her Infinite Variety*:

Words cannot portray, nor artists reproduce adequately the beauty of our evening skies. Low-lying crimson and pearl-tinted cloud-banks sometimes line the western horizon as the day ends. Through these the sun sends in thousands of broken arrows of silver light. The shafts strike the overhanging cumulus and lose themselves in scintillating mosaics of blue and amber, emerald and ruby. Rosy reflections of the western glory mirror themselves in fleecy cloud-puffs in the eastern sky seemingly supported by ascending darkness, and gradually these fade into heliotrope and bronze. Turning again to the sunset pageant, one finds the landscape sheathed in an aurora of rose and turquoise tints spreading far to the north and southward; and wherever lie lakelets or streamlets there appear shapes

Staff of Saskatchewan Government Photographic Services
Regina, SK
Photographer unknown / ca. 1955
GERRY SAVAGE COLLECTION

of molten crimsons among the deepening shadows like huge opals floating in a vast, quivering image.

An individual who made his reputation as both a photojournalist and an artistic photographer—especially of prairie skies and sunsets—and who was able to put into words his ideas of prairie photography was R. H. (Rusty) Macdonald. Born in 1915, his interest in photography started in his university days. On graduation, he began his career as a writer/photographer with the Regina *Leader-Post* in 1938. This was interrupted by World War II, during which he served in the RCAF and contributed stories and photographs to the air base's newsletter.

In 1949 he joined the *Western Producer* as a feature writer. He soon worked his way up to executive editor, a post he held from 1953 until his retirement in 1977. As a writer, Macdonald sought out and recorded stories of rural people and events in all three Prairie provinces. Wherever he journeyed, he took his cameras along. Many of his images, especially his colour transparencies, were published in the *Western Producer* and its weekend magazine section, but a large number of his black-and-white negatives were simply filed away in his basement.

Macdonald was inspired by a conversation he once had with a rural old-timer, who said, "There's beauty on the prairie—you've just got to work a little harder to find it." He spent the rest of his life finding it. Macdonald was a member of an informal gathering of between five and seven photographers (called informally the Labour Day Photo Group, reflecting the weekend each year when they met) who would take annual excursions to photograph prairie scenery. Other members included Wilfred West, a Regina commercial photographer, Thomas Melville-Ness, a fellow writer/photographer with the *Western Producer*, Ken Liddell, a *Leader-Post* and later *Calgary Herald* writer/photographer, Harold Kreutzwieser, Cliff Shaw, and Larry Shaw, a photographer for the *Leader-Post*. During long hours on the road, the group engaged in critical and theoretical debate over artistic photography and the prairie. "Grain elevators were the artistic debate of the day," Macdonald later recalled in a *Leader-Post* article on 10 October 1975. "Wilf West used to say that elevators were scenic. Do you know that people were actually ashamed of them? I suppose because we were colonial-minded. But elevators only began to be used as an art form in the *Leader-Post*."

Macdonald developed his own approach and eventually established his own working structure, "a sort of trinity on the prairies—a trinity of land, light and sky." He felt a photographer had to develop a thorough knowledge of the many types of western weather—how it progressed in all seasons, and what the resulting clouds, sunlight, precipitation, and rainbows would look like from different directions. He also felt that one needed to acquire an appreciation for the prairie—its flatness, its curves, its colours, its shades and, most of all, its interaction with the sky, and when one or the other became dominant. He felt that he could not sit and let a scene come to him. Instead, he had to contemplate the sky and light, and seek out and travel to the unique image. According to a *Leader-Post* article, Macdonald's work was "the result of a quick eye, a ready camera, and the energy (and luck) it takes to drive at 90 miles per hour for 250 miles to circumnavigate an interesting cloud formation and snap that terrific picture."

Although many of his images appeared in newspapers and journals, it was not until he had been accumulating prairie scenes for thirty-five years that it occurred to Macdonald to assemble a book. In short order, he turned out three impressive volumes: *Four Seasons West: A Photographic Odyssey of the Three Prairie Provinces* (1976), *Saskatchewan Landscapes* (1980), and *Alberta Landscapes* (1982, with Grant MacEwan).

Although prairie dwellers have made an energetic and valiant attempt to assert some control over their environment, almost all have arrived at the bittersweet realization that their efforts have been fleeting, that they are insignificant compared to the looming presence of the elements. There is a feeling that emerges from prairie photographs, a fleeting glimpse of aloneness, even loneliness. Human activities and structures are dwarfed by geography, and by that subtle and looming presence, implied by the photographer or inferred by the viewer. Photographs show that we are not masters of our domain, nor should we be. There is something more important behind the background, something beyond the full grasp of the senses. We are impermanent in comparison to the elements.

Prairie photography is not electric in its impact. It must be viewed time and again. It must be allowed to reveal its subtle pleasures and understanding, whether it is a sunburned farmer's face or a lone house on the great plain. This book is intended as an introduction to those subtle pleasures.

The Land

The Canadian prairies are bounded by the Rocky Mountains to the west, the 49th parallel to the south, the Canadian Shield to the east, and a diagonal line north-west from Lake Winnipeg to the Peace River district. Its sheer size beggars the imagination. Many have tried to dismiss it as boring, uniform, endlessly the same. It is anything but. Across this vast expanse are grasslands and parklands, rolling hills, uplands and lowlands, coteaus, and plains as smooth and flat as a table top. Numerous river systems run through the region: the Red, the Assiniboine, the Souris, the Qu'Appelle, the North and South Saskatchewan, the Bow, the Athabasca, the Sturgeon, and the Milk, as well as an assortment of lakes, large and small.

Aside from a handful of surprisingly sophisticated and cosmopolitan cities, a few dozen smaller cities and sizeable towns, and hundreds of widely scattered small towns and villages (many of them in decline), most of the region has been, and remains, without significant human settlement. In land mass, Saskatchewan alone is four times the size of England, but it boasts less than 1.5% of that nation's population. The prairies are home, however, to a huge variety of flora and fauna, many of which have become identified with the region. The prairie chicken, the gopher, the bison, the wild horse, the cabri, the wapiti, the coyote, even the locust figure prominently in the memoirs, fiction, and visual culture of the region. And every outdoor rural prairie photograph includes the omnipresent wild grasses, the tiger lily, the crocus, wild sage, carragana, and, in the south, cacti.

Even if there were no human activity, the seasons of the Canadian prairie would be a constantly renewing source of inspiration to the photographer.

"The Prairie: Looking West"
Red River, MB
Humphrey Lloyd Hime / September-October 1858
PROVINCIAL ARCHIVES OF MANITOBA, N10831

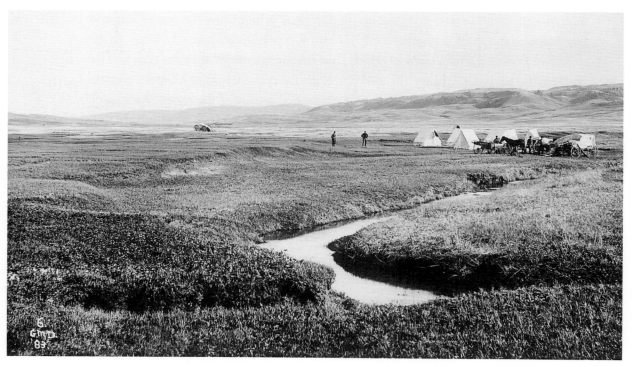

Surveyors camp near head of Big Plume Creek
Cypress Hills, SK
George M. Dawson / Geological Survey of Canada / 1883
GLENBOW ARCHIVES, NA–302–5

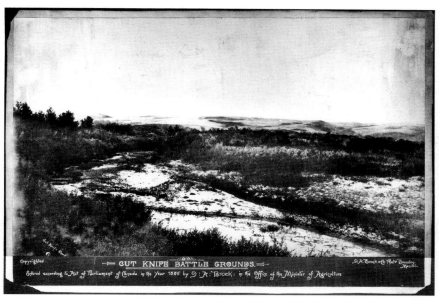

"Cut Knife Battle Grounds"
Cut Knife Creek, SK
J. A. Brock / October 1885
NATIONAL ARCHIVES OF CANADA, PA–31492

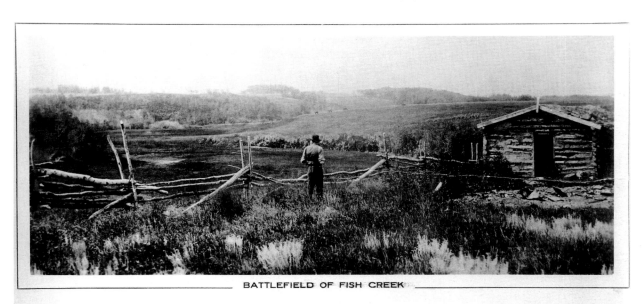

From an original photograph taken immediately after the
engagement of April 24th, 1885.

Compliments of
ALLAN CAMERON

"Battlefield of Fish Creek"
Fish Creek, SK
Photographer unknown / April 1885
SASKATCHEWAN ARCHIVES BOARD, R–B2826

"Ross Creek"
Near Medicine Hat, AB
Photographer unknown / 1906
B. Silversides Collection

"In the Valley of the Birdtail"
Near Birtle, MB
Photographer unknown / ca. 1910
B. SILVERSIDES COLLECTION

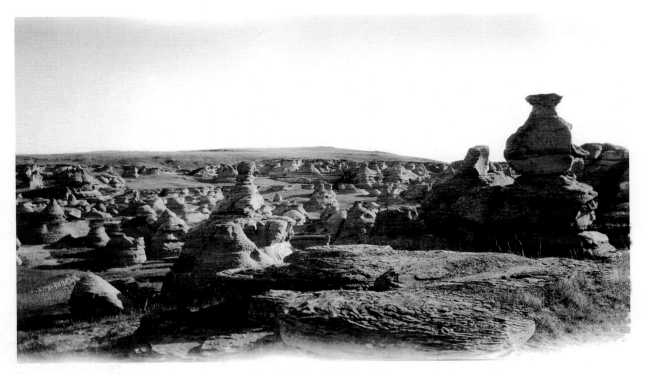

Sandstone Hoodoos
Milk River district, AB
Photographer unknown / 1929
GLENBOW ARCHIVES, NA–711–201

A copse of birch trees on the prairie
Probably Qu'Appelle Valley, SK
Photographer unknown / ca. 1920
SASKATCHEWAN ARCHIVES BOARD, R–B134(1)

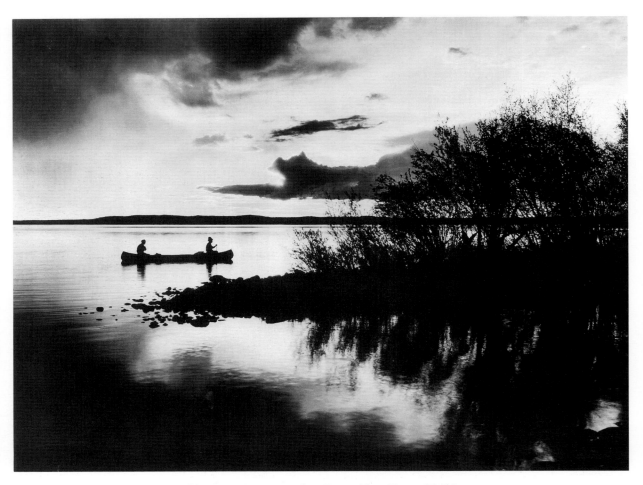

"Sunset on Kingsmere Lake—Prince Albert National Park"
Prince Albert National Park, SK
William J. Oliver (attrib.) / ca. 1935
BRITISH COLUMBIA ARCHIVES AND RECORDS SERVICE, G–2536

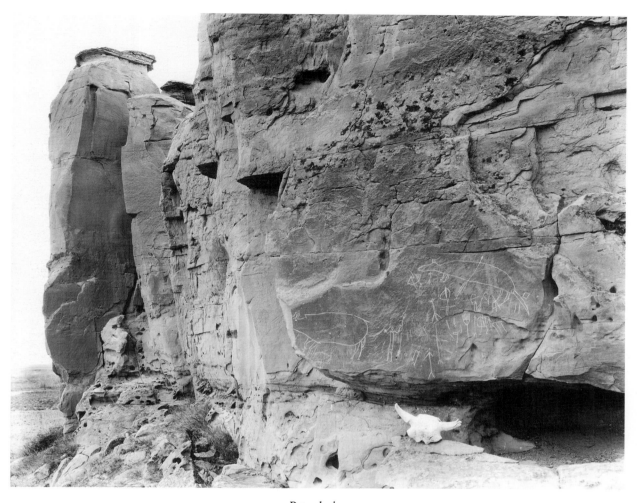

Petroglyphs
Writing on Stone, AB
William J. Oliver / ca. 1920
GLENBOW ARCHIVES, ND–8–495

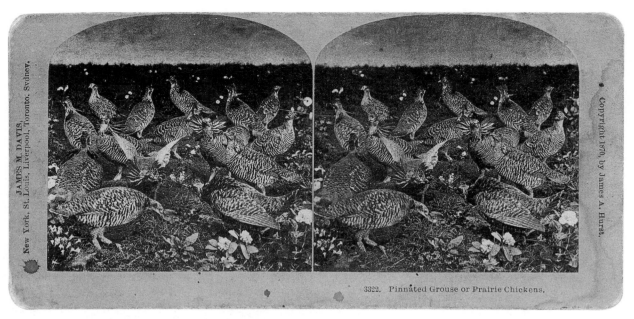

"Pinnated Grouse or Prairie Chickens"—stereograph
Western Canada
James A. Hurst, published by B.W. Kilburn / 1870
B. Silversides Collection

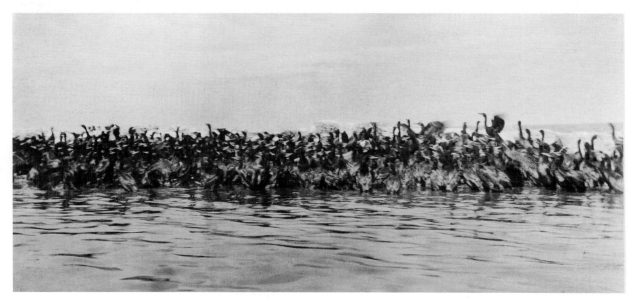

Young Cormorants—an intriguing effect from a slow shutter speed
Last Mountain Lake, SK
A. C. Lloyd / ca. 1920
Saskatchewan Archives Board, S–B1879

"Martins' Nests"—under gable of Government House, one half of stereograph
Battleford, SK
Cornelius J. Soule / Summer 1884
SASKATCHEWAN ARCHIVES BOARD, S–B6598

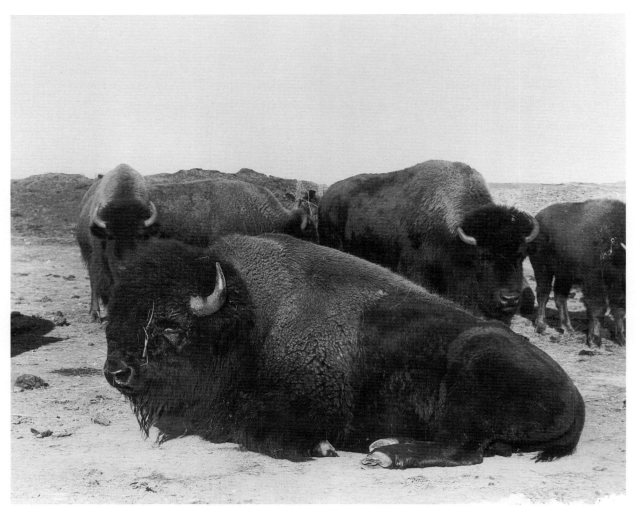

"Last of the Canadian Buffaloes"
Silver Heights near Winnipeg, MB
Frederick Steele / Steele & Co. / 1890s
NATIONAL ARCHIVES OF CANADA, C–10041

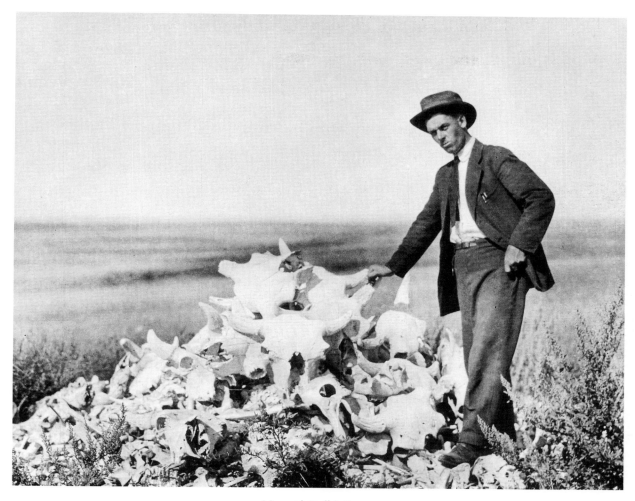

Man with Buffalo Bones
Near Medicine Hat, AB
Photographer unknown / ca. 1910
MEDICINE HAT MUSEUM & ART GALLERY, PC255.33

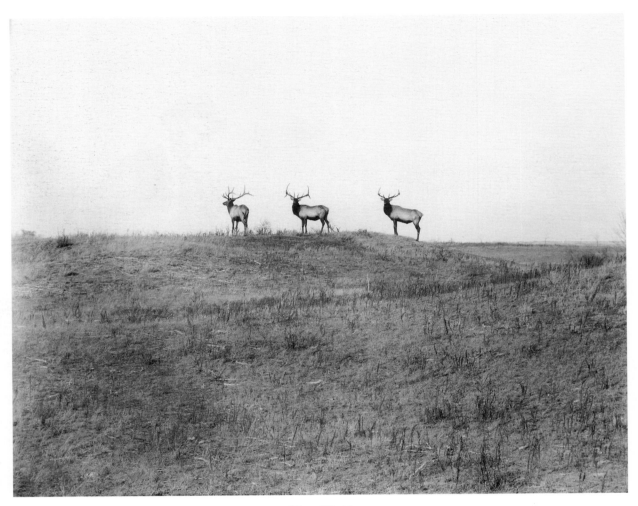

Three Wapiti
Wainwright, AB
John Henry Gano / ca. 1920
GLENBOW ARCHIVES, ND-18-26

Horses watering in Saskatchewan River
Central Saskatchewan
Russell Holmes (Rusty) Macdonald / ca. 1946
SASKATCHEWAN ARCHIVES BOARD, S–RM–B1930

Prairie lilies on a front porch
Saskatoon, SK
Saskatoon *Star-Phoenix* / 20 June 1955
SASKATCHEWAN ARCHIVES BOARD, S–SP–3412(2)

Mentzelia Decapetalia
(Evening Star)
Maple Creek, SK
Geraldine Moodie / 1898
UNIVERSITY OF TORONTO—
THOMAS FISHER RARE BOOK
LIBRARY, CHAMBERLAIN FONDS,
112 (BOX 14)

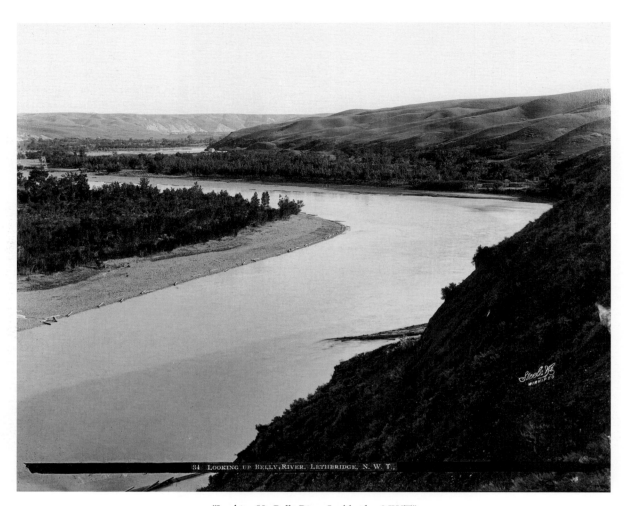

"Looking Up Belly River, Lethbridge, NWT"
Lethbridge, AB
Frederick Steele / Steele & Co. / ca. 1896
SASKATCHEWAN ARCHIVES BOARD, R–B1552

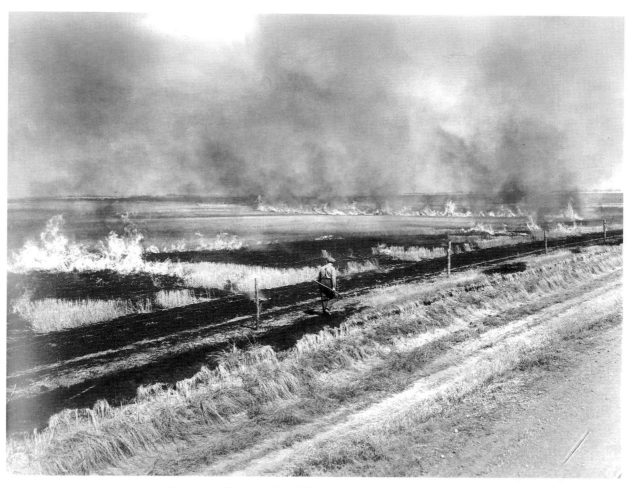

Burning stubble on the Sandy Partridge farm gets out of control
Near Saskatoon, SK
Saskatoon *Star-Phoenix* / 11 May 1951
SASKATCHEWAN ARCHIVES BOARD, S–SP–655–3

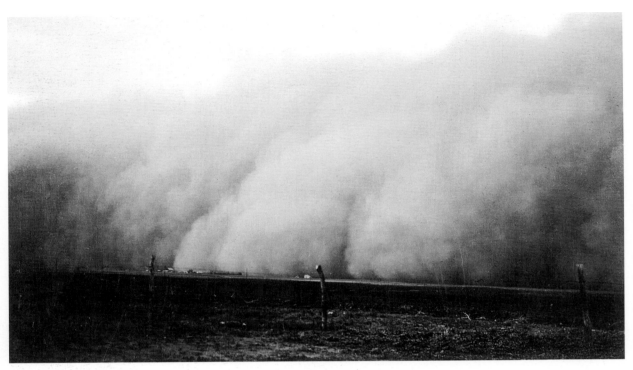

Approaching dust storm
Near Nanton, AB
Photographer unknown / 1930s
GLENBOW ARCHIVES, NA–3535–84

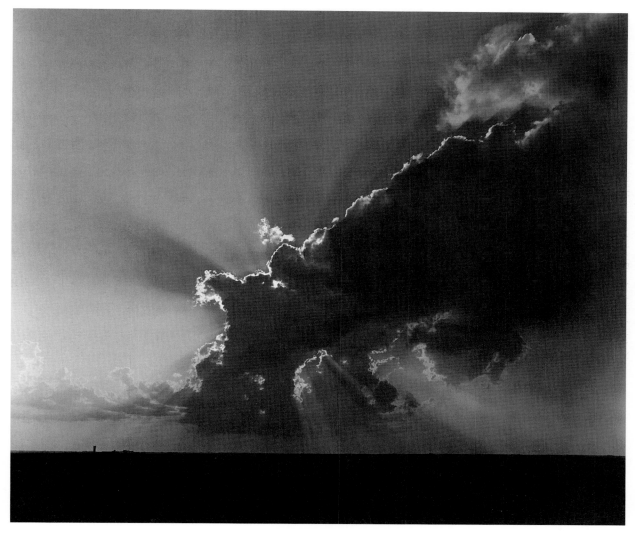

Prairie sunset behind cloud
Western Canada
Russell Holmes (Rusty) Macdonald / ca. 1960
SASKATCHEWAN ARCHIVES BOARD, S–RM–B2529

The People

The Canadian prairies were the sole preserve of the First Nations—chiefly the Cree, the Blackfoot Confederacy, the Assiniboine, the Sioux, the Dakota, and the Ojibwa—until the first half of the 18th century, when a European presence was felt for the first time as explorers and traders began to move into the vast lands drained by Hudson Bay. In the second half of that century, the Hudson's Bay Company, and later the North-West Company, established inland trading posts along the rivers of the region. A first attempt at European agricultural settlement was made at Red River on the site of present-day Winnipeg in 1812.

The mixing of the Indian and European races resulted in a new people, the Métis, who settled around the trading posts but were seasonally nomadic. A large and growing number made their home at Red River until the time of the first North-West Rebellion in 1869-70. After that they moved west, fanning out along the rivers of Saskatchewan.

With the incorporation of Manitoba and the North-West Territories into Canada, large-scale organized settlement was begun. After the suppression of the second North-West Rebellion in 1885 and the completion of the CPR, a veritable torrent of incomers invaded the region, starting with Central and Maritime Canadians. Then numerous European peoples were lured to the west, and there was a period of intense settlement from 1890 to 1912. They were a diverse group: Ukrainians, Doukhobors, Mennonites, Hutterites, Poles, Jews, Icelanders, Swedes, Hungarians, Romanians, Mormons, and American Blacks. For many years they congregated in their own communities and kept their own language. Many groups have since assimilated into the prevailing British-North American society; others have avoided it to this day. All have contributed to the combined character of the region.

The variety of appearances, styles of dress, customs, activities, and ceremonies of prairie people have provided endless subject matter for photographers. And because each ethnic group has traditionally had its own knowledgeable and sympathetic photographic chroniclers, each has added to the amazing diversity of social documentation.

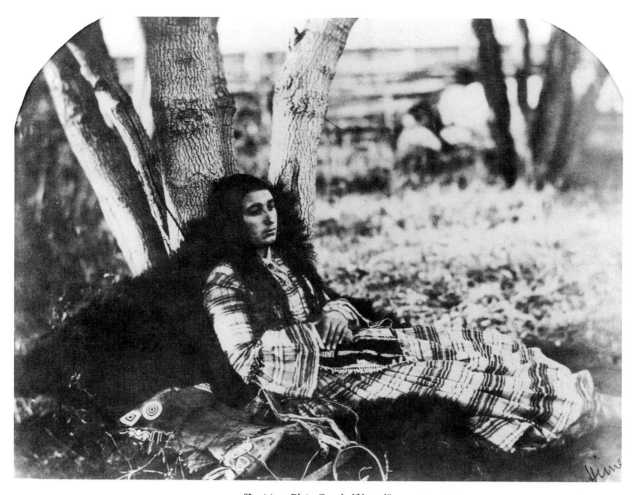

"Letitia: a Plain Cree half-breed"
Red River, MB
Humphrey Lloyd Hime / September-October 1858
PROVINCIAL ARCHIVES OF MANITOBA, N12576

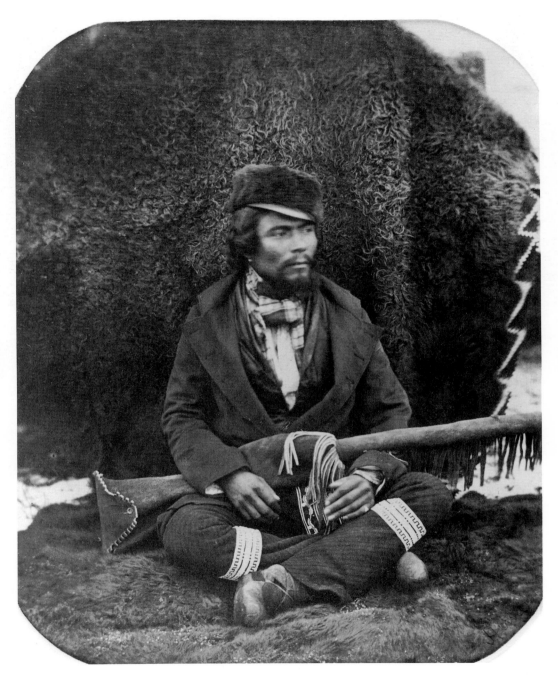

"Wigwam: an Ojibway half-breed"
Red River, MB
Humphrey Lloyd Hime / September-October 1858
PROVINCIAL ARCHIVES OF MANITOBA, N12578

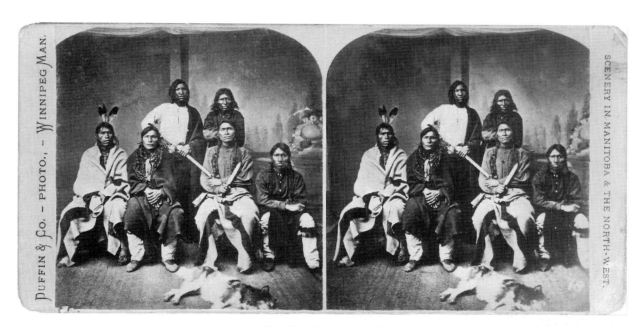

"Dog Feast"—stereograph
Winnipeg, MB
Simon Duffin / Duffin & Co. / ca. 1875
B. SILVERSIDES COLLECTION

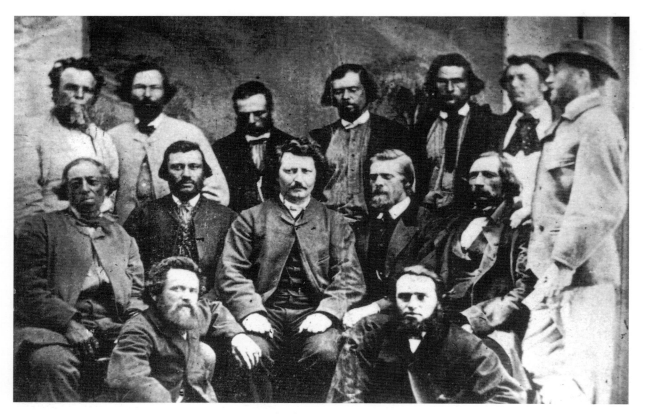

Louis Riel and Provisional Government
Red River, MB
Joseph Langevin (attrib.) / 3 June 1870
PROVINCIAL ARCHIVES OF MANITOBA, N5396

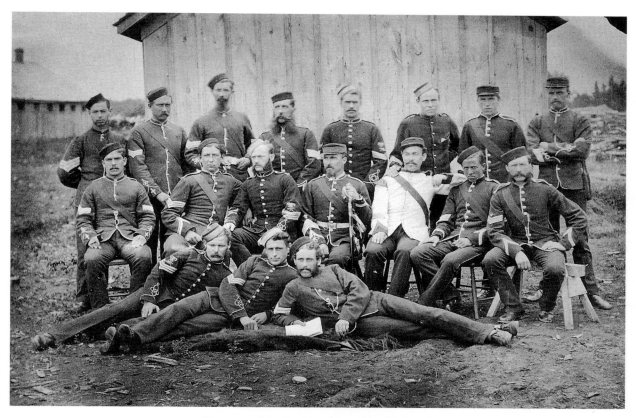

"Sergeants of the Provisional Battalion of Infantry"
—under command of Major A.G. Irvine
Fort Garry, MB
Photographer unknown / 1872
GLENBOW ARCHIVES, NA–354–22

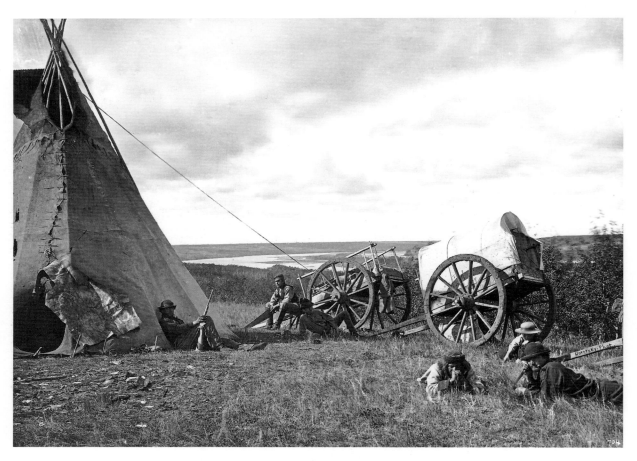

Survey Camp at elbow of North Saskatchewan River
Central Saskatchewan
Charles Horetzky / September 1871
NATIONAL ARCHIVES OF CANADA, PA–9170

Big Bear's Encampment
Near Maple Creek, SK
George M. Dawson / Geological Survey of Canada / 6 June 1883
NATIONAL ARCHIVES OF CANADA, PA–50749

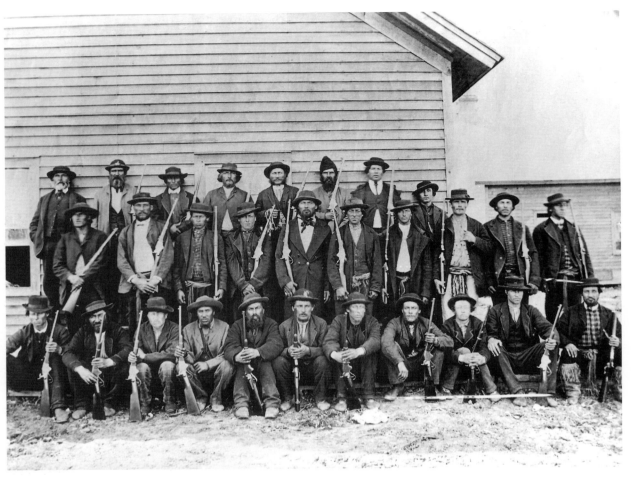

Métis Scouts
Dufferin, MB
Royal Engineers / North American Boundary Commission / 1874
SASKATCHEWAN ARCHIVES BOARD, R–B635

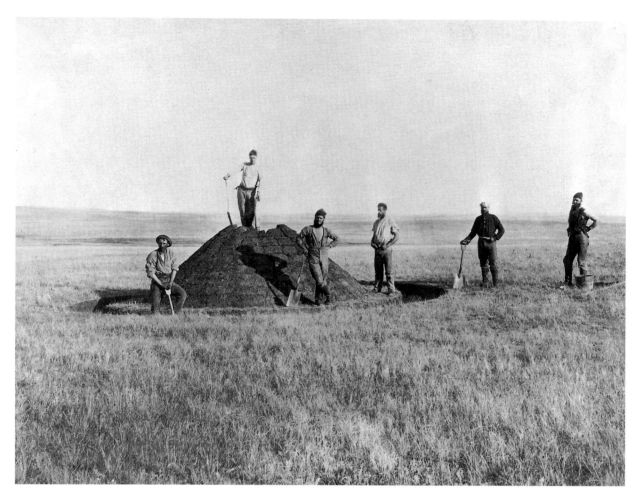

Sappers building a boundary mound
Southern Saskatchewan
Royal Engineers / North American Boundary Survey / August-September 1873
NATIONAL ARCHIVES OF CANADA, C–73304

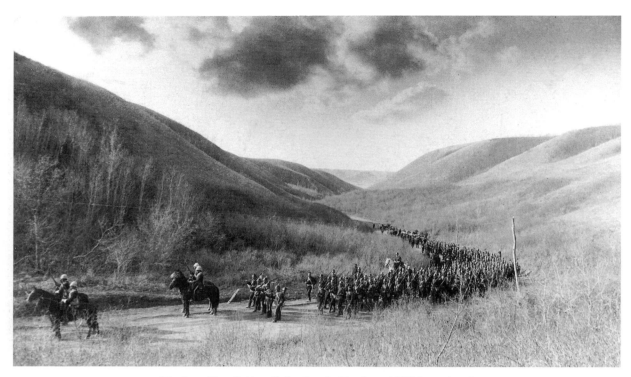

"Coulee at Fort Qu'Appelle heading for Touchwood Hills"—12th and
13th Regiments, Winnipeg Cavalry, and the York & Simcoe Batteries
Fort Qu'Appelle, SK
Oliver B. Buell / 6 April 1885
NATIONAL ARCHIVES OF CANADA, PA–118748

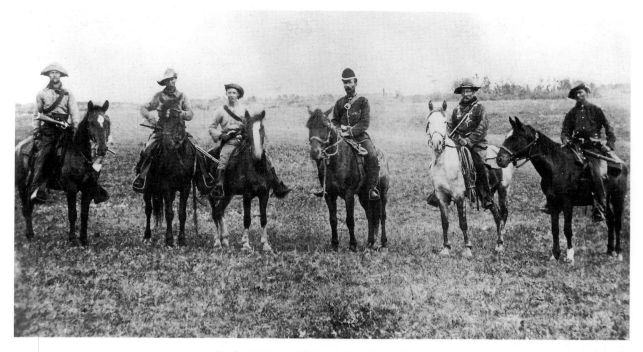

Boulton's Mounted Infantry, No. 2 Birtle Troop
Brandon, MB
J. A. Brock / April-May 1885
PROVINCIAL ARCHIVES OF MANITOBA, N10169

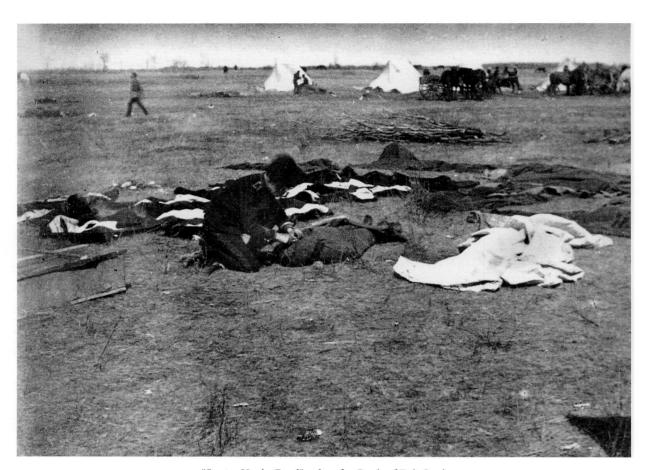

"Sewing Up the Dead"—day after Battle of Fish Creek
Fish Creek, SK
Captain James Peters / 25 April 1885
GLENBOW ARCHIVES, NA–363–29

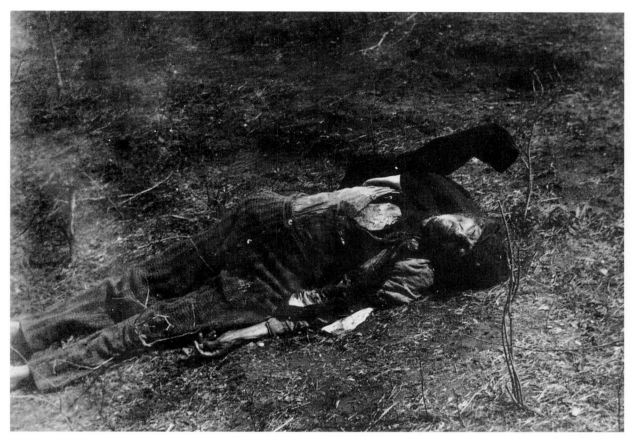

"Body of half-breed sniper (likely Donald Ross)
who killed Captain John French"
Batoche, SK
Captain James Peters / 12 May 1885
GLENBOW ARCHIVES, NA–363–47

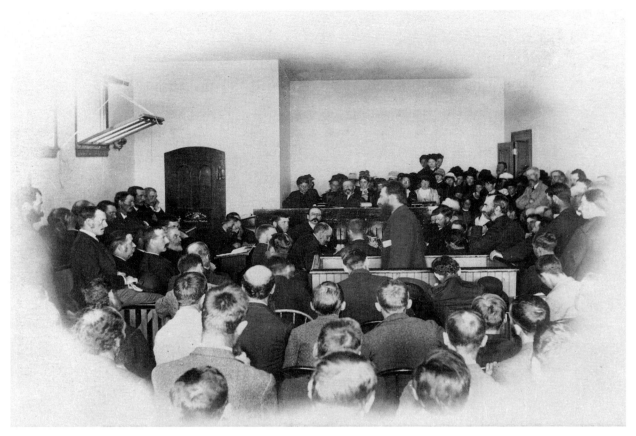

Louis Riel in the courtroom
Regina, SK
Oliver Buell / August 1885
NATIONAL ARCHIVES OF CANADA, C–1879

James H. Schofield, North-West Mounted Police
Fort Walsh, SK
George Anderton (attrib.) / June 1878
GLENBOW ARCHIVES, NA-1602-5

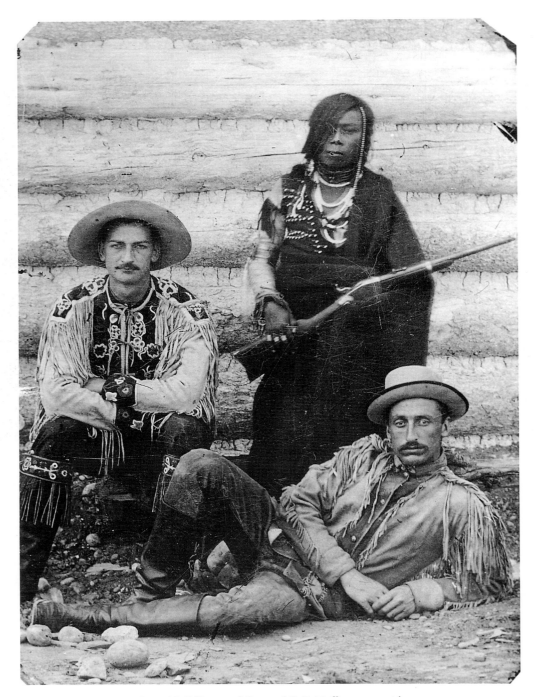

Constable F. Young and Corporal G. B. Moffat, NWMP, with
unidentified Blood Indian
Fort Walsh, SK
George Anderton (attrib.) / 1879
GLENBOW ARCHIVES, NA–136–2

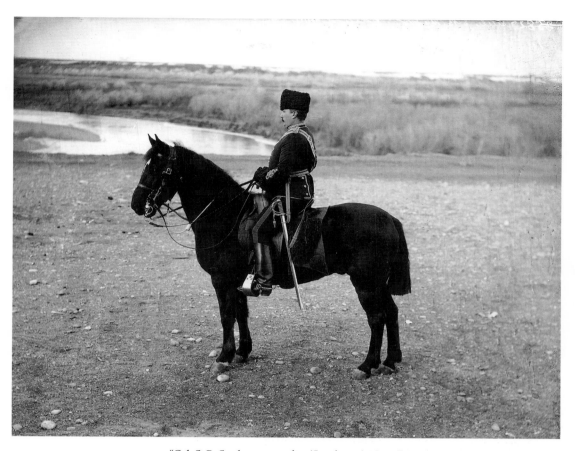

"Col. S. B. Steele, commanding 'Strathcona's Horse'"
Calgary, AB
Frederick Steele / Steele & Co. / 1900
SASKATCHEWAN ARCHIVES BOARD, R–B1351

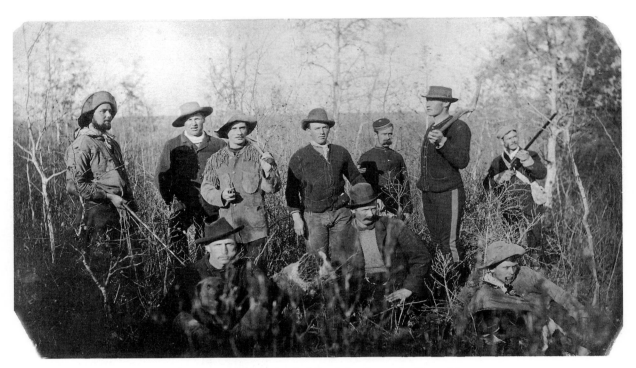

Hunting Party—left to right, Grebble, Callas, Loscombe, Depar, Merry,
Domereig, Meredith, Montgomery, unknown, unknown
Near Battleford, SK
Cornelius J. Soule (attrib.) / 1884
SASKATCHEWAN ARCHIVES BOARD, S–B11212

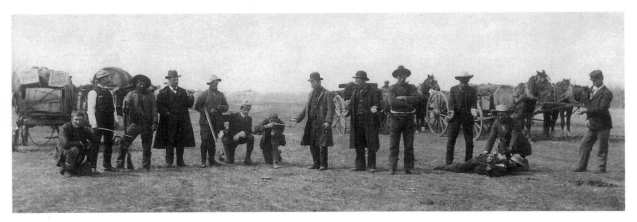

"Freighters"
Probably on Battleford Trail, SK
William J. James / ca. 1898
SASKATCHEWAN ARCHIVES BOARD, S–B10307

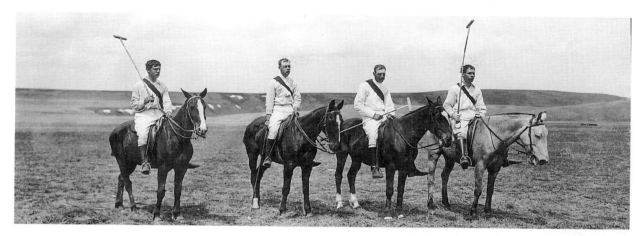

"English Polo Team, at Roo Dee Ranche, near Pincher Creek, Alta."
Pincher Creek, AB
Frederick Steele / Steele & Co. / 24 May 1899
GLENBOW ARCHIVES, NA–659–85

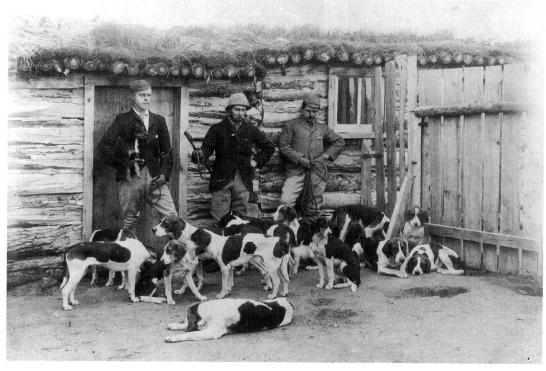

Riding to the Hounds
Cannington Manor, SK
Adam B. Thom / ca. 1894
UNIVERSITY OF SASKATCHEWAN LIBRARY, SPECIAL COLLECTIONS,
MORTON MANUSCRIPT COLLECTION, C555 / 2 / 14.17

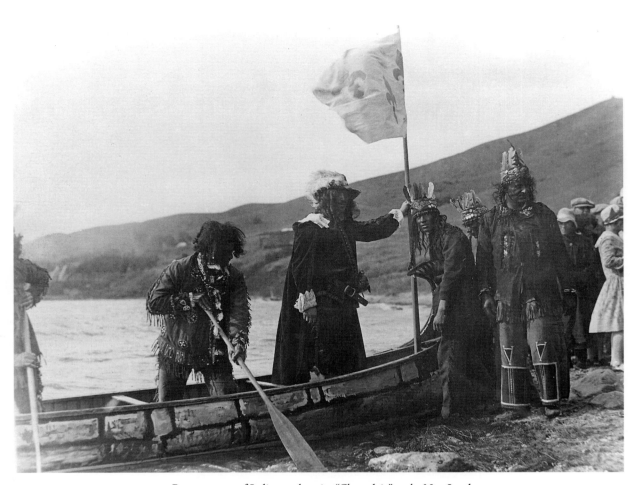

Re-enactment of Indians welcoming "Champlain" to the New Land
Lebret, SK
Photographer unknown / 15 August 1925
SASKATCHEWAN ARCHIVES BOARD, R–B922

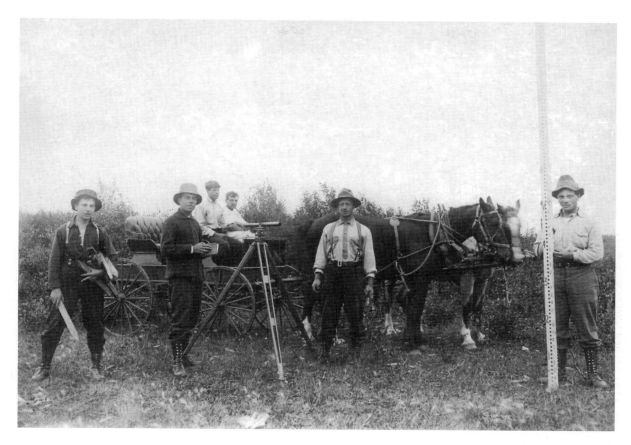

Survey party
Tyndall, MB
Ernest Kaye / n.d.
B. SILVERSIDES COLLECTION

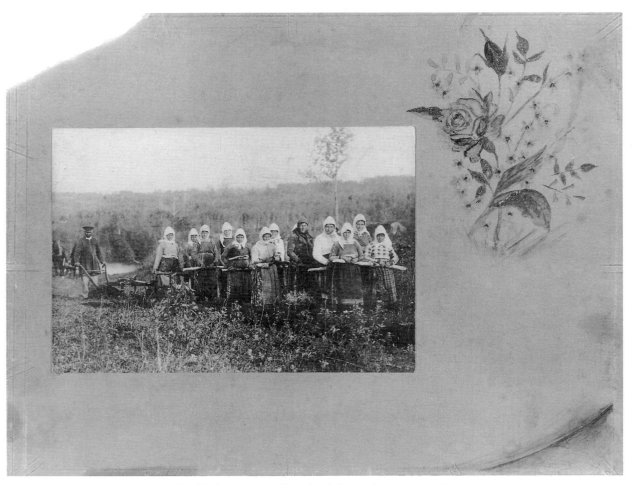

Doukhobor women pulling plough (on handpainted mount)
Swan River, MB
Welford / ca. 1902
UNIVERSITY OF SASKATCHEWAN LIBRARY,
SPECIAL COLLECTIONS, C555 / 1 / 4.2G

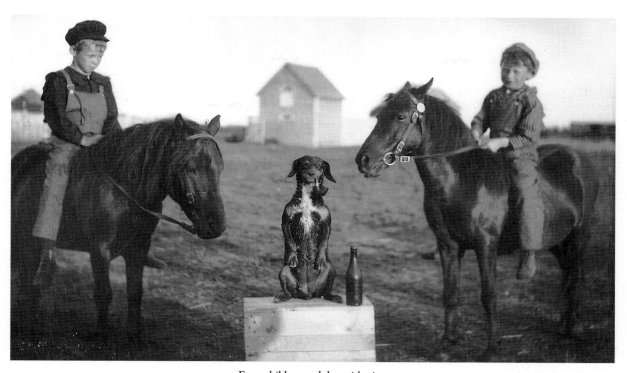

Farm children and dog with pipe
Prince Albert district, SK
Photographer unknown / ca. 1910
SASKATCHEWAN ARCHIVES BOARD, S99–19 / 12

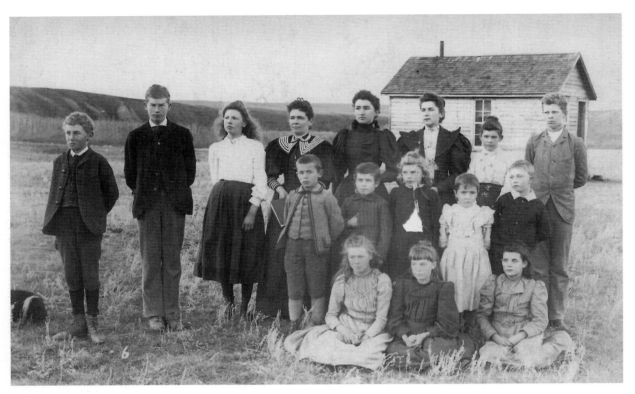

Students of Wascana School
Old Crossing, SK
William C. Lusk / 1895
B. SILVERSIDES COLLECTION

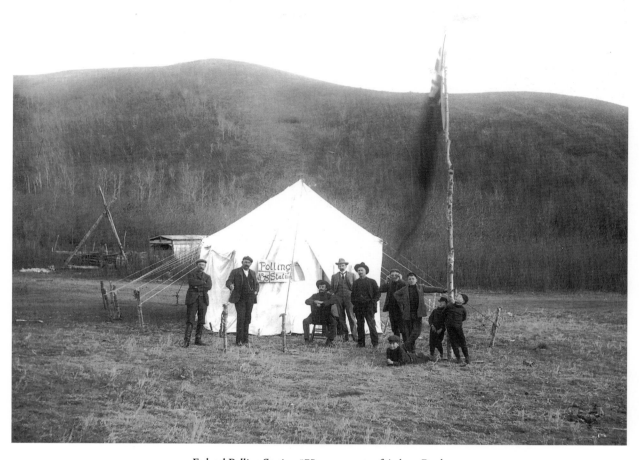

Federal Polling Station #75 on property of Aubrey Rook
Fort Qu'Appelle, SK
Douglas John Munroe / 3 November 1904
SASKATCHEWAN ARCHIVES BOARD, R–B1776

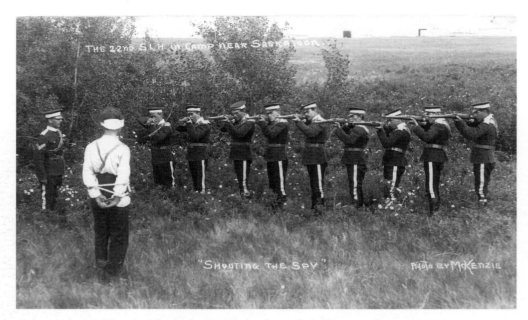

"Shooting The Spy"—22nd Saskatchewan Light Horse, mock execution
Near Saskatoon, SK
Peter McKenzie / 1909
SASKATOON PUBLIC LIBRARY–LOCAL HISTORY DEPARTMENT, #LH3342

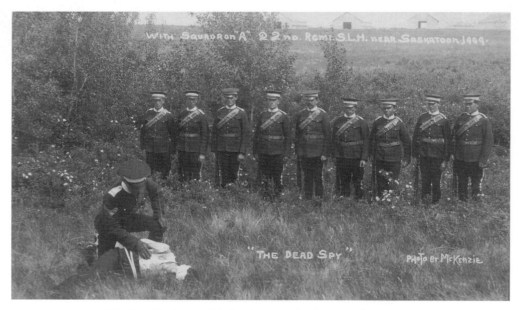

"The Dead Spy"—22nd Saskatchewan Light Horse, mock execution
Near Saskatoon, SK
Peter McKenzie / 1909
SASKATOON PUBLIC LIBRARY—LOCAL HISTORY DEPARTMENT, #LH695

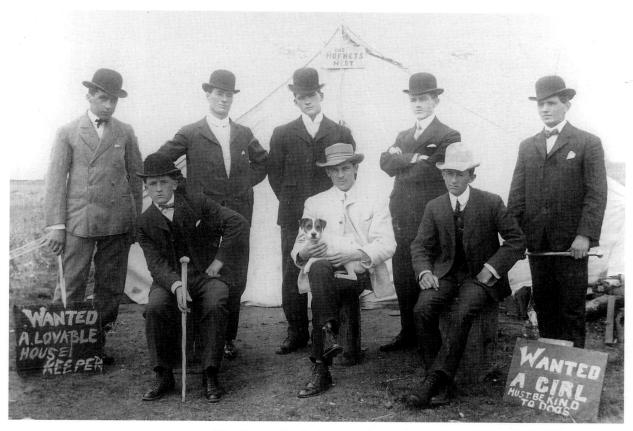

"The Hornet's Nest"—bachelors of Saskatoon
Saskatoon, SK
Ralph Dill (attrib.) / ca. 1905
SASKATOON PUBLIC LIBRARY—
LOCAL HISTORY DEPARTMENT, #LH3348

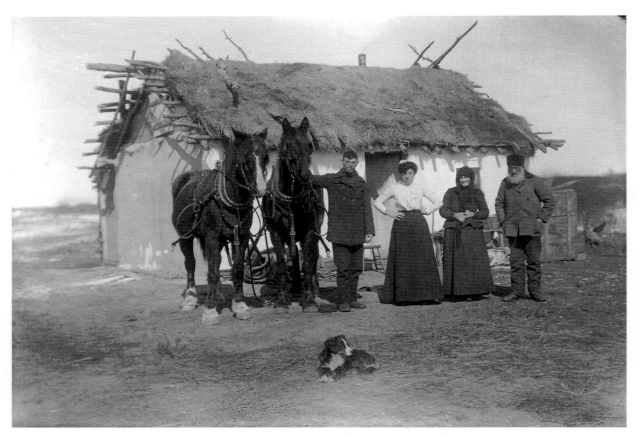

Samuel and Hannah Schwartz with daughter and son-in-law
(members of the Jewish Colonization Society)
Near Lipton, SK
Douglas John Munroe / ca. 1903
SASKATCHEWAN ARCHIVES BOARD, R–B1781

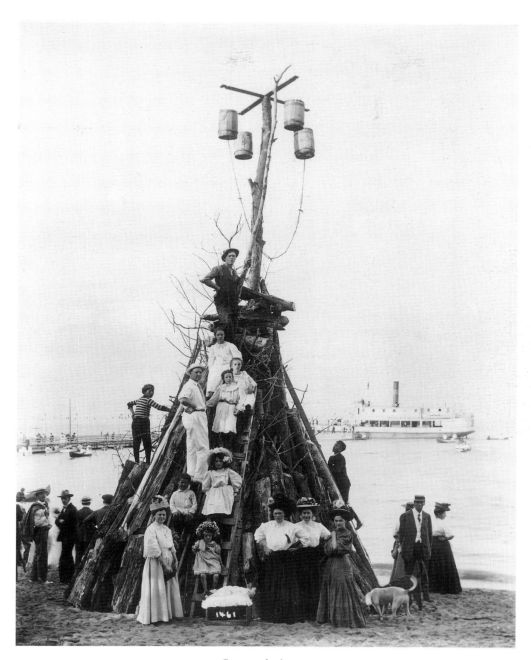

Gun powder beacon
Winnipeg Beach, MB
Lewis B. Foote / 1909
PROVINCIAL ARCHIVES OF MANITOBA, N2190

Mr. & Mrs. Oldham—a seasoned farm couple pose on the prairie
Western Canada
Photographer unknown / 1914
B. SILVERSIDES COLLECTION

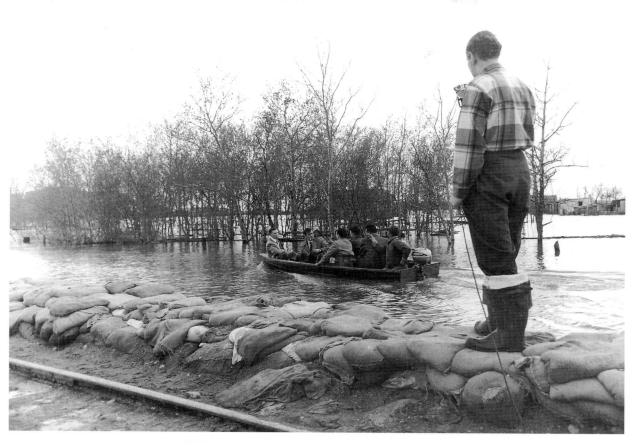

CBC announcer at McGillivray Dike during Winnipeg flood
Winnipeg, MB
Photographer unknown / 1950
PROVINCIAL ARCHIVES OF MANITOBA, N17155

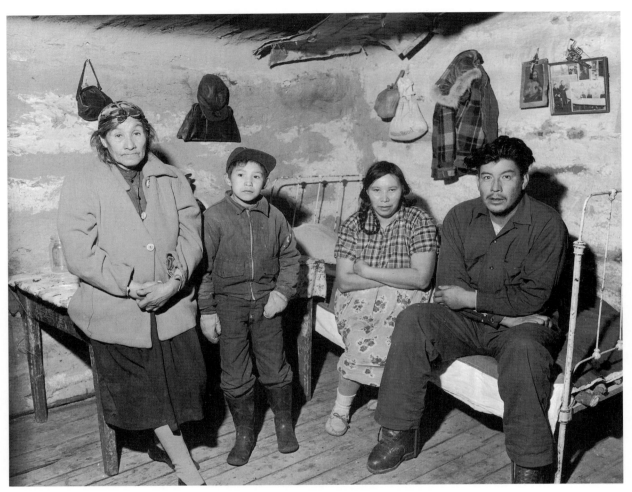

Leo Nicotine and family
Red Pheasant Reserve, SK
Munroe Murray / Saskatoon *Star-Phoenix* / 10 December 1956
SASKATCHEWAN ARCHIVES BOARD, S–SP–5986–12

The Structures

Just as there is no homogenous prairie population, there is no homogenous prairie architecture. The human structures of the Canadian prairies have manifested a combination of the practical and the decorative, the temporary and the long term, the thrifty and the extravagant. The exigencies of everyday life dictated the priorities of design. The first necessity was protection from the elements, then self-sufficiency, and finally aesthetics.

A number of structures were the result of interactions between humans and nature. The tipi, the sod house, and the mud house (or burdei) were all constructed of materials found close at hand. Others arose from the connection between the land and the commercial activities carried out on it. The grain elevator, the potash storage bin, grain hopper bins, the coal tipple, and the oil derrick all evolved out of the various methods of storing or handling prairie commodities.

Still others have no tie to the prairie. Some designs emmigrated along with people from the "old country," wherever that old country might be. These designs, altered to fit local conditions, resulted in many and curious hybrid structures. They are a record of how these immigrants used to live, and how they adapted to the new land. Others are derivative and meant only to impress. They are of interest as examples of humankind's perennial conceit, and in showing how aspects of western Canadian society wanted to be viewed.

"No generation of people here has lived like the last, and none has constructed buildings resembling those of their fathers," wrote architectural historian Trevor Boddy in his 1980 essay, "Notes for a History of Prairie Architecture."

The only given in prairie architecture is change. Photographs may be the most accurate and enjoyable means of charting those changes, of gaining an understanding of where prairie people have lived, worked, worshipped, studied, and conducted the public's business.

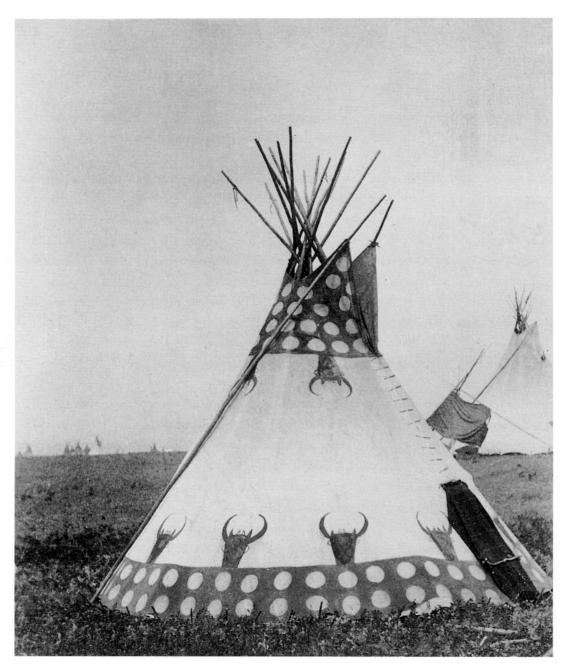

Buffalo Head tipi
Blood Reserve, AB
Robert N. Wilson / 1894
GLENBOW ARCHIVES, NA–668–17

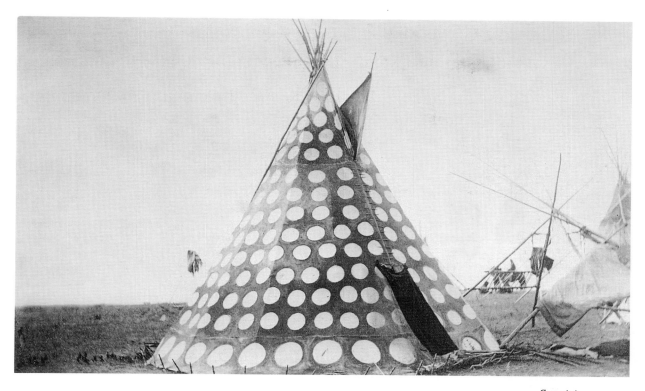

Star tipi
Blood Reserve, AB
Robert N. Wilson / 1892
GLENBOW ARCHIVES,
NA–668–10

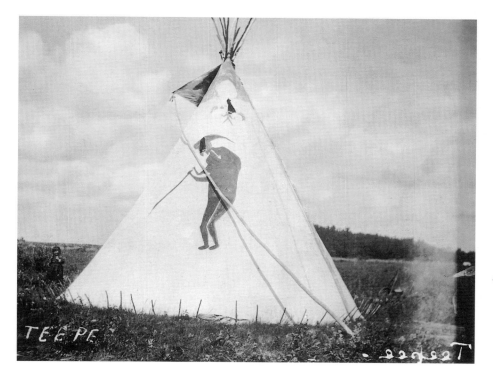

TEEPE

"Teepe"— [possibly indicating
home of an elder]
Near Qu'Appelle Valley, SK
Photographer unknown / n.d.
SASKATCHEWAN ARCHIVES
BOARD, R–A2166

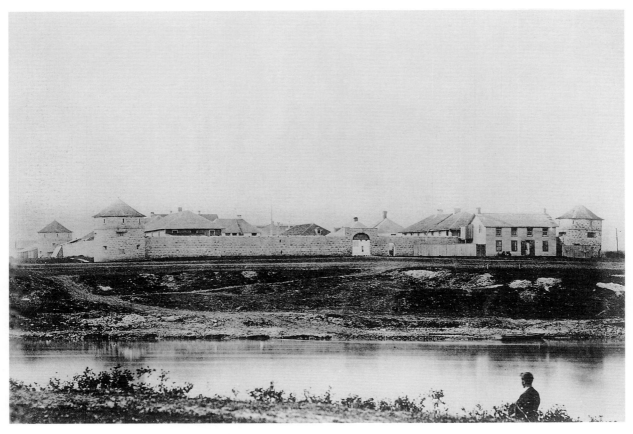

Fort Garry
Red River, MB
Photographer unknown / ca. 1880
GLENBOW ARCHIVES, NA–54–13

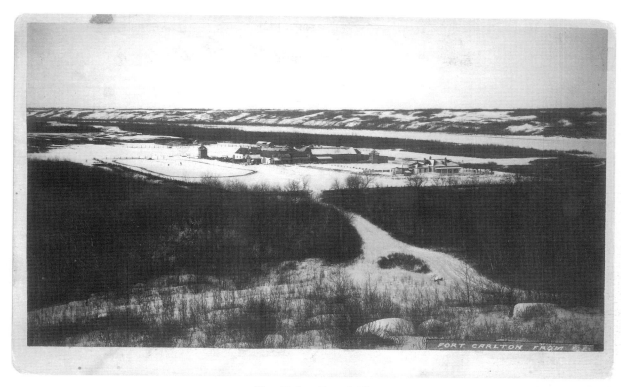

"Fort Carlton From S. E."
Fort Carlton, SK
Cornelius J. Soule / Spring 1884
SASKATCHEWAN ARCHIVES BOARD, S–B135

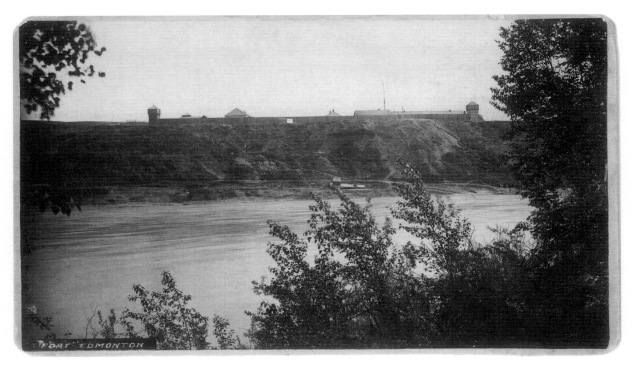

"Fort Edmonton"
Edmonton, AB
Cornelius J. Soule / Summer 1884
SASKATCHEWAN ARCHIVES BOARD, A186, VIII.1

Fort Walsh
George Anderton / ca. 1879
MEDICINE HAT MUSEUM AND GALLERY, P235.2

Fort Calgary
Calgary, AB
George M. Dawson / Geological Survey of Canada / August 1881
GLENBOW ARCHIVES, NA–235–2(A)

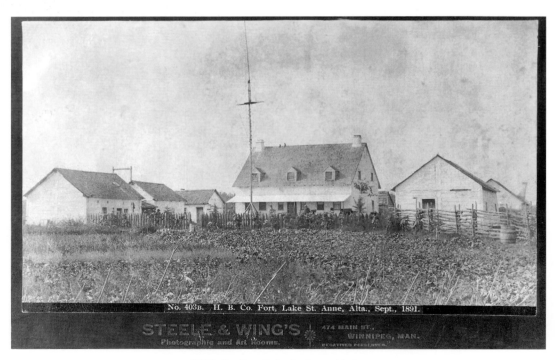

No. 403B. H. B. Co. Fort, Lake St. Anne, Alta., Sept., 1891.

"H.B. Co. Fort, Lake St. Anne, Alta"
Lac St. Anne, AB
Frederick Steele / Steele & Wing / September 1891
CITY OF EDMONTON ARCHIVES, EA–10–126

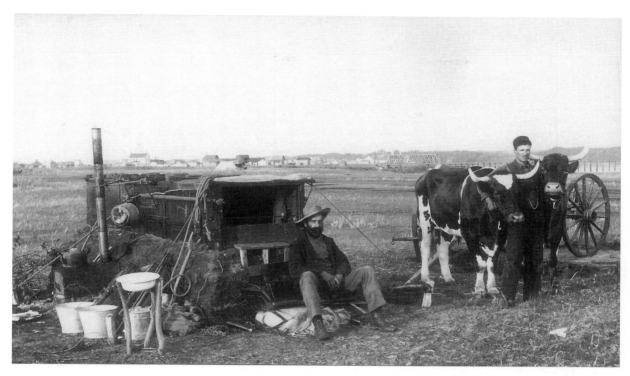

Pierre "Bon" Bernard and Stewart Bryson set up
temporary lodgings in their wagon box
Saskatoon, SK
Ralph Dill / Fall 1904
SASKATCHEWAN ARCHIVES BOARD, S–B9

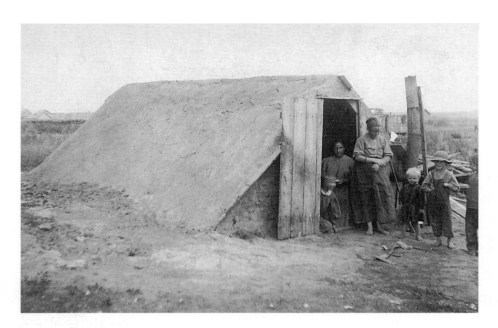

Ruthenian's first dwelling—
clay mud covered frame
building
Rosthern district, SK
Photographer unknown /
Fall 1903
B. Silversides Collection

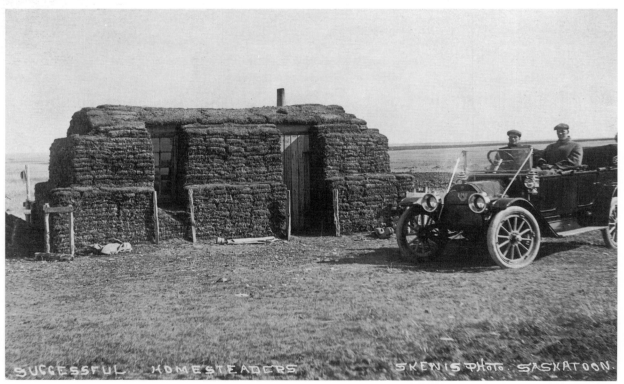

"Successful Homesteaders"
Saskatoon district, SK
Benjamin Skewis / ca. 1912
B. Silversides Collection

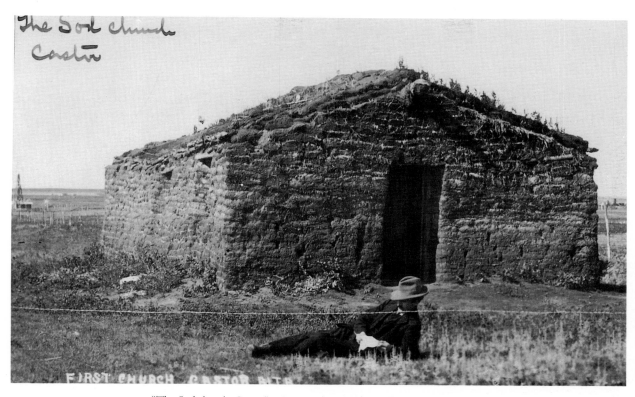

"The Sod church, Castor"—Rev. Appleton in front of Castor's first church
Castor, AB
Photographer unknown / ca. 1912
GLENBOW ARCHIVES, NA–2332–7

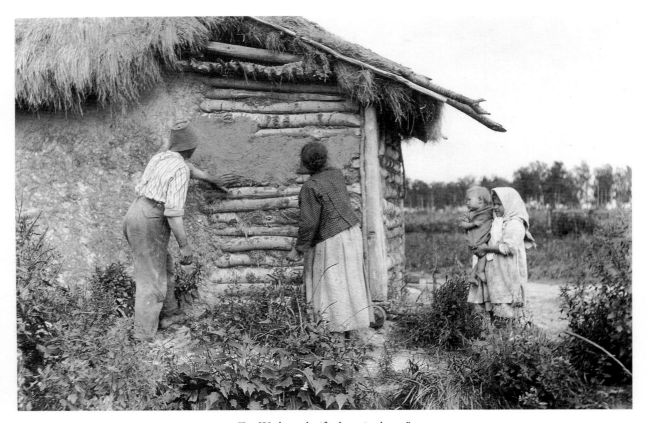

"Joe Wacha and wife plastering house"
Near Vita, MB
W.J. Sisler / 1916
PROVINCIAL ARCHIVES OF MANITOBA, N9631

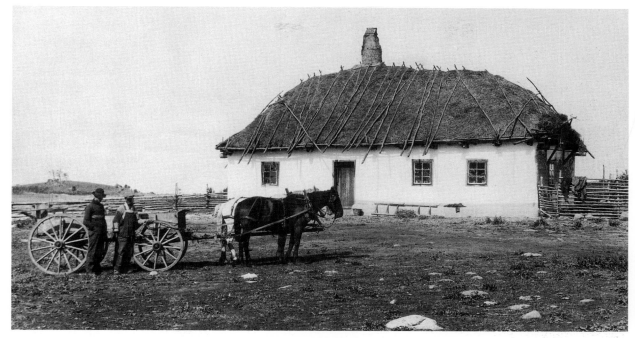

"Ruthenian Farm Home"
Vegreville district, AB
Canadian National Railways / 1910
University of Saskatchewan Archives,
Hans Dommasch Fonds, MG 172, D / 2 / III / c

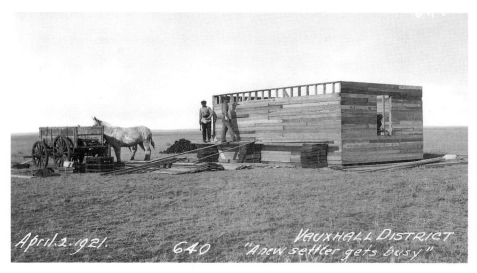

"A New Settler Gets Busy"
Vauxhall district, AB
Photographer unknown / 2 April 1921
Prairie Farm Rehabilitation Administration

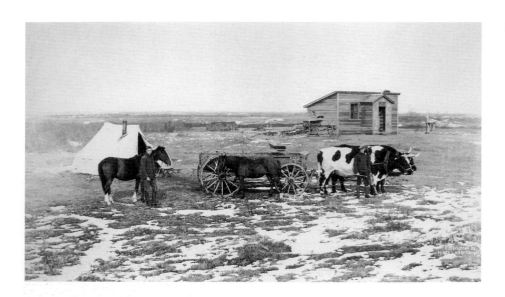

Homesteader's oxen, wagon, and new home
Southern Alberta
Harry Pollard / ca. 1905
GLENBOW ARCHIVES,
NA–4780–4

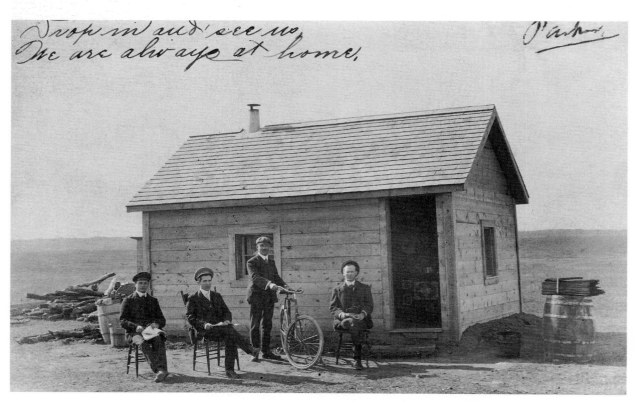

"Drop in and see us, We are always at home"
Battleford district, SK
Photographer unknown / n.d.
SASKATCHEWAN ARCHIVES BOARD, S–B10836

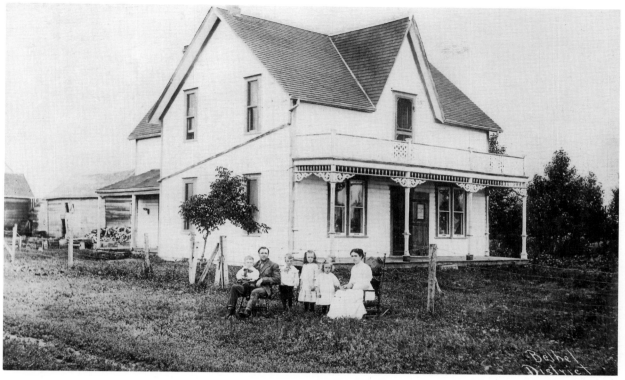

"Bethel District"—A. Hennan and family
Roland, MB
B. Cowe (attrib.) / ca. 1910
B. SILVERSIDES COLLECTION

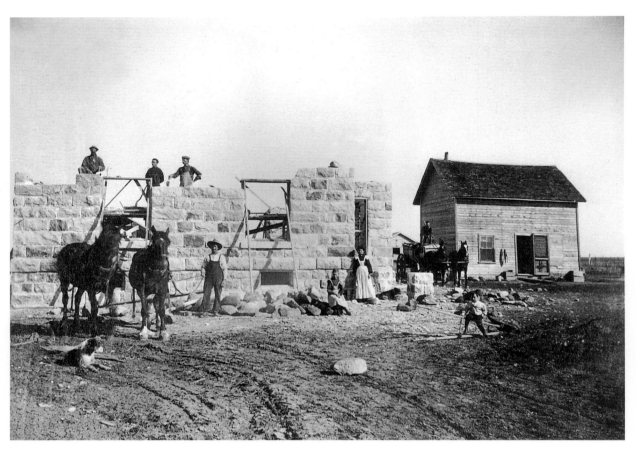

"Farm House in course of construction"
Near Moose Jaw, SK
Photographer unknown / 1906
GLENBOW ARCHIVES, NA–303–214

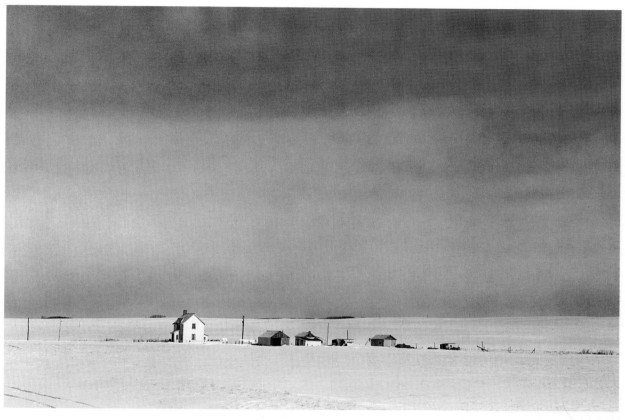

Farm house in winter
Saskatoon district, SK
Thomas Melville-Ness / ca. 1948
SASKATCHEWAN ARCHIVES BOARD, S–MN–B3653

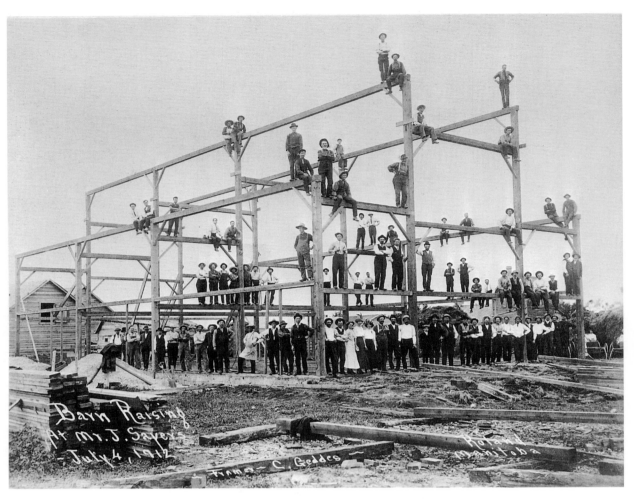

"Barn Raising At Mr. J. Sayer's—Framer C. Geddes"
Roland, MB
B. Cowe (attrib.) / 4 July 1912
GLENBOW ARCHIVES, NA–406–3

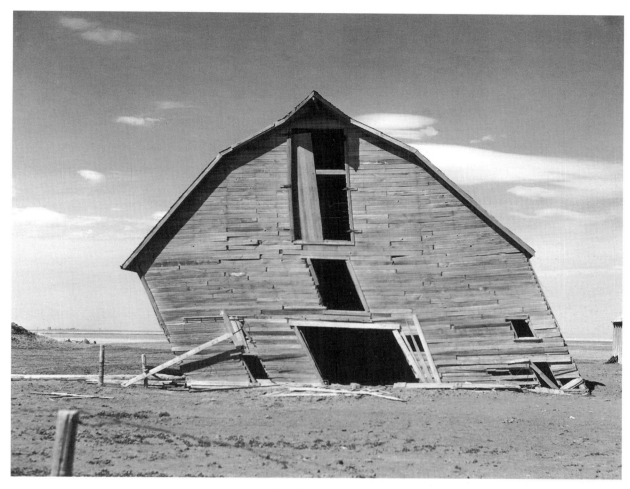

Barn frame shifting
Western Canada
Russell Holmes (Rusty) Macdonald / ca. 1950
SASKATCHEWAN ARCHIVES BOARD, S–RM–B2266

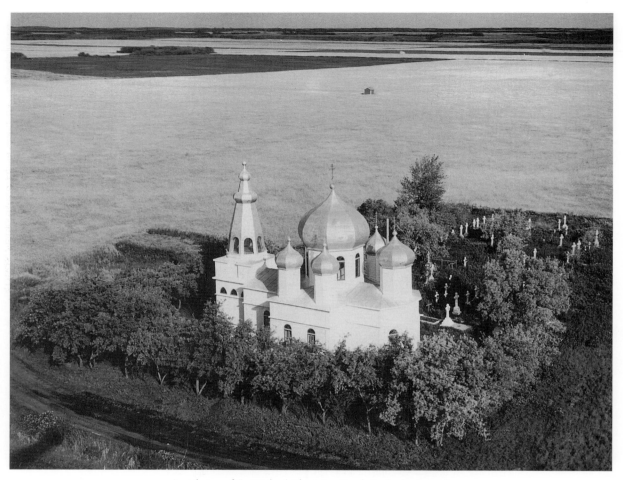

Aerial view of St. Michael Ukrainian Greek Orthodox Church
Wakaw, SK
Hugh McPhail / McPhail Airways / 1955
SASKATCHEWAN ARCHIVES BOARD, S–B5976

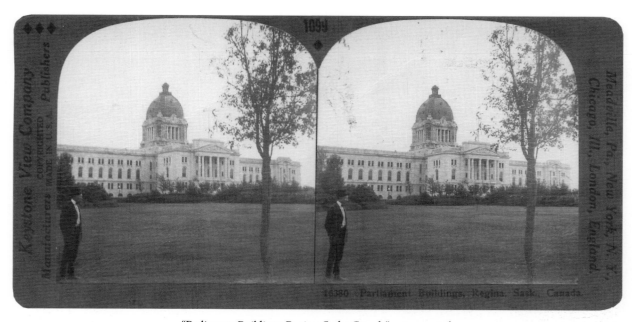

"Parliament Buildings, Regina, Sask., Canada"—stereograph
Regina, SK
Keystone View Company / ca. 1912
B. Silversides Collection

Interior view of kiln, Dominion
Fire Brick Plant—gas fire boxes along wall
Claybank, SK
Ralph Vawter / Saskatchewan Government Photo Services / April 1961
SASKATCHEWAN ARCHIVES BOARD, 61–058–12

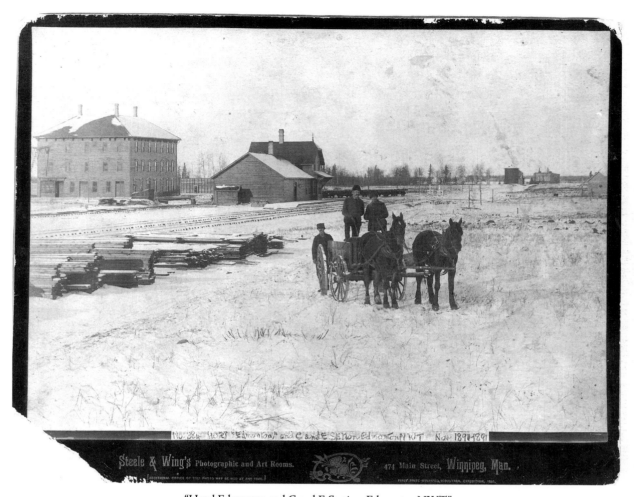

Steele & Wing's Photographic and Art Rooms. 474 Main Street, Winnipeg, Man.

"Hotel Edmonton and C and E Station, Edmonton NWT"
—now the Strathcona Hotel on Whyte Avenue
Strathcona, AB
Frederick Steele / Steele & Wing / November 1891
CITY OF EDMONTON ARCHIVES, EA–10–1291

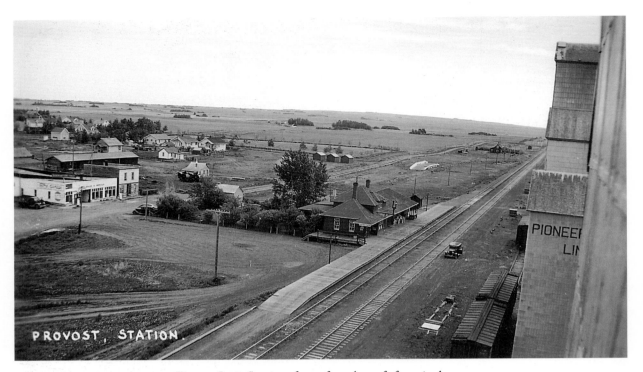

"Provost Station"—view of town from the roof of a grain elevator
Provost, AB
Photographer unknown / ca. 1910
B. Silversides Collection

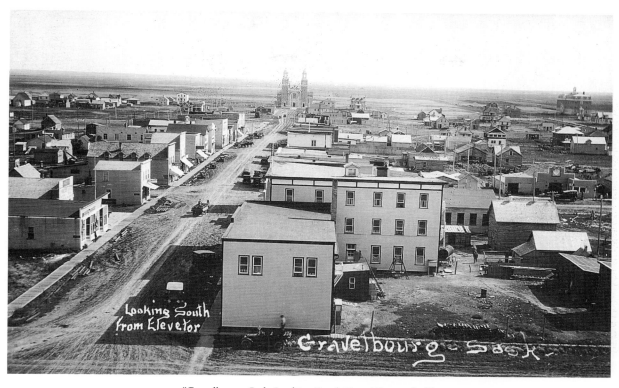

"Gravelbourg, Sask, Looking South From Elevetor [*sic*]"
Gravelbourg, SK
Photographer unknown / September 1922
B. Silversides Collection

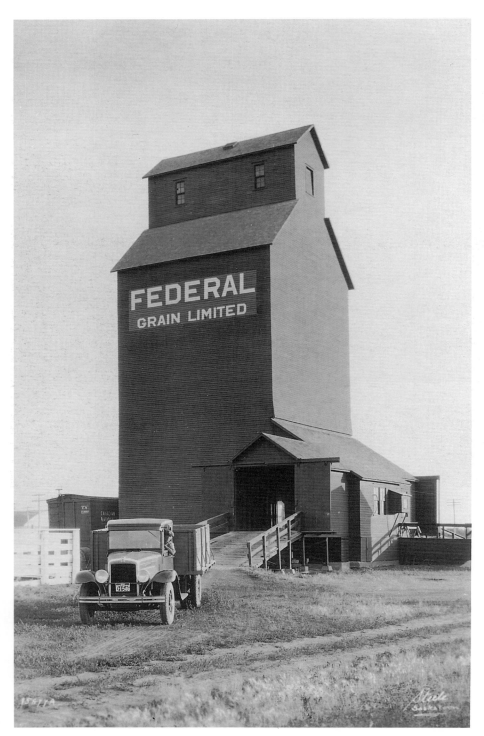

Federal grain elevator
Saskatoon, SK
Frederick Steele / 1930
SASKATOON PUBLIC LIBRARY—
LOCAL HISTORY DEPARTMENT,
#LH551

Grain elevator and prairie sunset
Western Canada
Russell Holmes (Rusty) Macdonald / ca. 1950
SASKATCHEWAN ARCHIVES BOARD, S–RM–B1743

Transportation

Given the huge area and the distances between settlements on the Canadian prairies, transportation has always been a concern. The earliest land transportation was the horse. Introduced in the 1700s, it quickly became the favoured means of transportation among First Nations, not only as a riding animal but as a beast of burden: a horse-pulled travois could carry much more than the smaller dog-pulled travois of previous generations. In the larger society, the horse became associated with other means of transportation, such as the wagon, the stagecoach, the carriage, and democrat. In the transport of freight, however, the ox was the favoured animal. Because of its strength, it was considered more versatile for farming applications as well.

The pivotal moment in prairie history was arguably the completion of the Canadian Pacific Railway in 1885. It allowed the smooth and rapid passage of settlers and goods to the west and the easy return of western products, chiefly grain and beef, to the east. The construction of the other two transcontinental railways cemented the east-west connection and their reciprocal economies.

The first automobiles appeared on the prairies at the turn of the 20th century. While they fascinated people, they were definitely a luxury, and were slow to catch on. Yet by the early 1920s a rudimentary highway system was established, and travel between major centres was generally a dusty but safe experience. Interprovincial highways did not become a fact of life until the 1940s. By the following decade prairie Canadians had embraced the automobile, and its continued popularity was assured by the construction of the Trans-Canada highway and the subsequent decline of the passenger railway.

Water travel, too, has always played a major role in prairie life. The earliest mode of aquatic transportation, of course, was the canoe. Designed by Native peoples thousands of years before the arrival of Europeans, it was used to good effect by the early voyageurs. However, fur trade companies soon came to favour the shallow-drafted York boat, which was capable of carrying huge loads of supplies and furs.

Following the lead of the American West, the age of the steamboat arrived on the Canadian prairies in the 1860s. It was inaugurated on the Red River when most communication with the outside world—and the first shipments of wheat—went through Minnesota. Subsequently, paddle-wheelers plied the North and South Saskatchewan Rivers with passengers and freight until about 1910, by which time the railways could service any point on the river system. Since the 1950s, prairie waterways have been home to pleasure craft only.

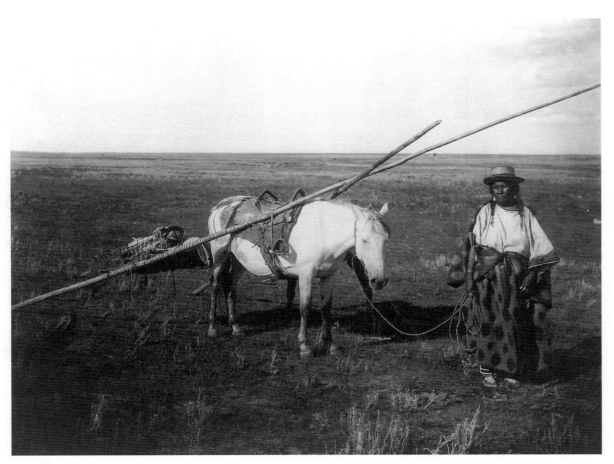

Woman with travois
Blackfoot Reserve, AB
Norman Caple / N. Caple & Co. / ca. 1895
CITY OF VANCOUVER ARCHIVES, IN.P.75,N.145

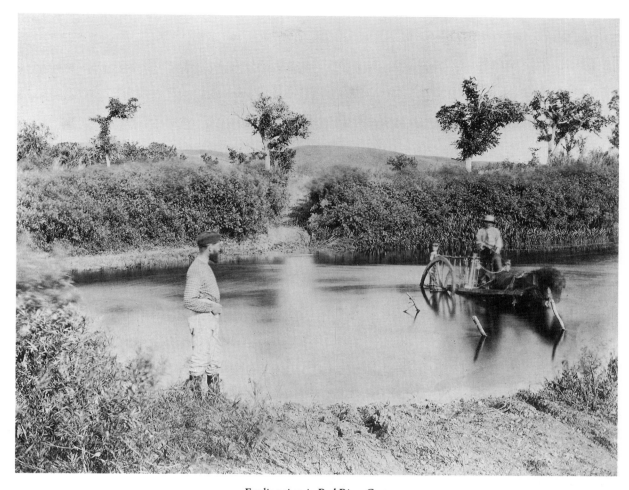

Fording river in Red River Cart
Souris River, MB
Royal Engineers / North American Boundary Commission / 1872
SASKATCHEWAN ARCHIVES BOARD, R–A22

"Harold's Mom"—Alberta
Chapman on horseback
Western Canada
Photographer unknown /
ca. 1910
B. Silversides Collection

Katie Daniothy riding a pig
Southern Alberta
Ella Hartt / ca. 1900
GLENBOW ARCHIVES, NC–39–302

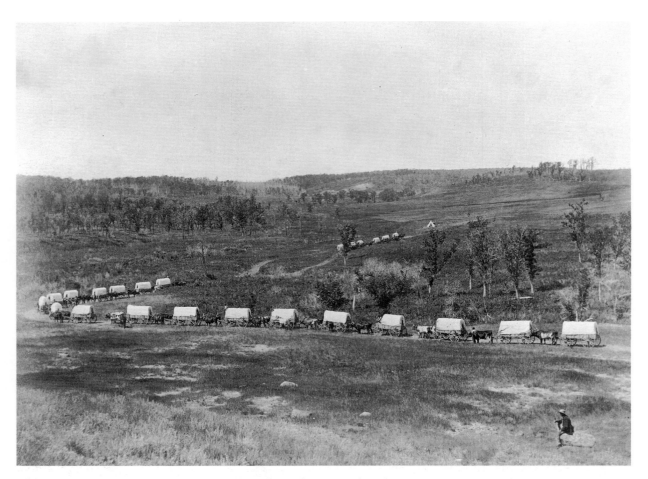

"Ox train crossing Dead Horse Creek on their way West"
53 miles west of Red River, MB
Royal Engineers / North American Boundary Survey / 1873
NATIONAL ARCHIVES OF CANADA, PA–74645

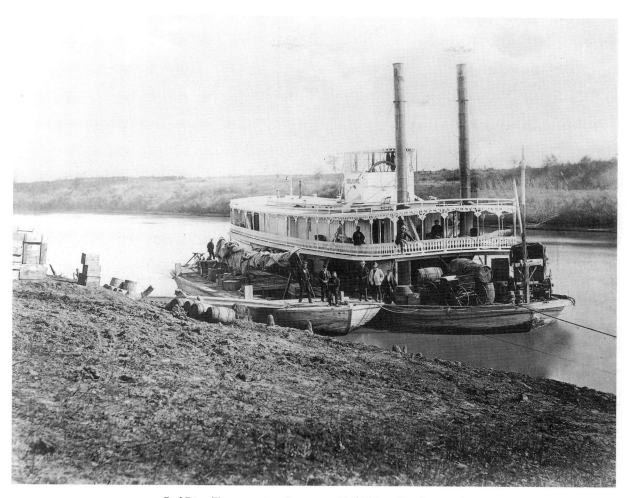

Red River Transportation Co. steamer "Selkirk" —offloading supplies
Red River, MB
Royal Engineers / North American Boundary Commission / 1873
PROVINCIAL ARCHIVES OF MANITOBA, N14022

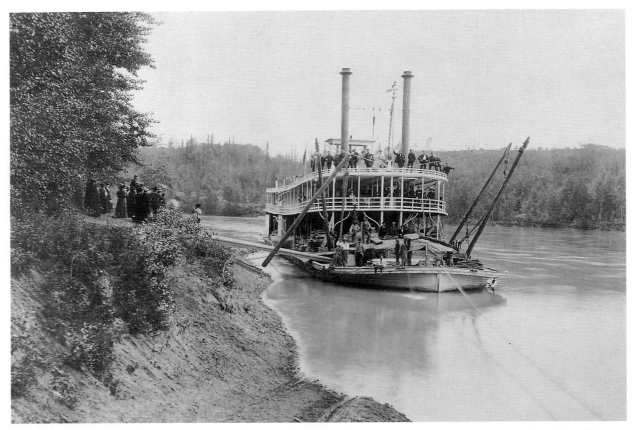

Steamer "North-West" leaving
on first trip of the season
for Prince Albert
Edmonton, AB
Charles W. Mathers / 1896
GLENBOW ARCHIVES,
NA-1036-13

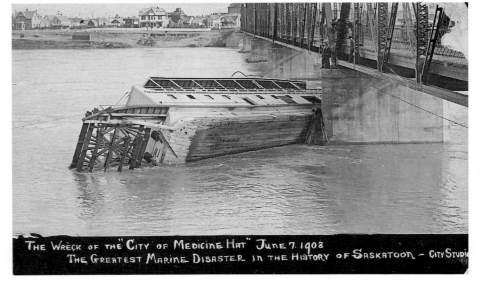

THE WRECK OF THE "CITY OF MEDICINE HAT" JUNE 7. 1908
THE GREATEST MARINE DISASTER IN THE HISTORY OF SASKATOON - CITY STUDIO

"The Wreck of the 'City of
Medicine Hat'—The Greatest
Marine Disaster in the
History of Saskatoon"
Saskatoon, SK
Peter McKenzie / City Studio /
7 June 1908
B. SILVERSIDES COLLECTION

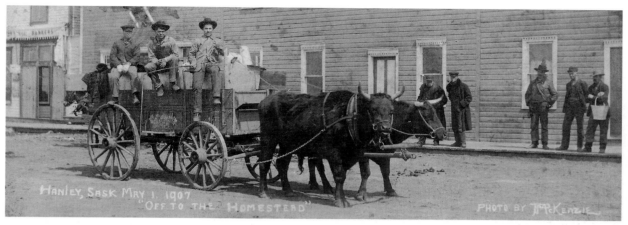

"Off To The Homestead"
Hanley, SK
Peter McKenzie / 1 May 1907
SASKATOON PUBLIC LIBRARY—
LOCAL HISTORY DEPARTMENT,
#LH1482

"Alf Price Trying Out His Racer"—racing a carriage up main
street so fast, the photographer was unable to stop motion
Lampman, SK
W. Forgay / 1915
SASKATCHEWAN ARCHIVES BOARD, S–B1622

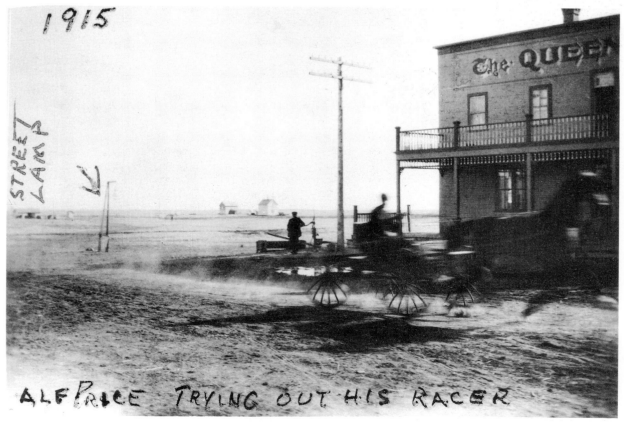

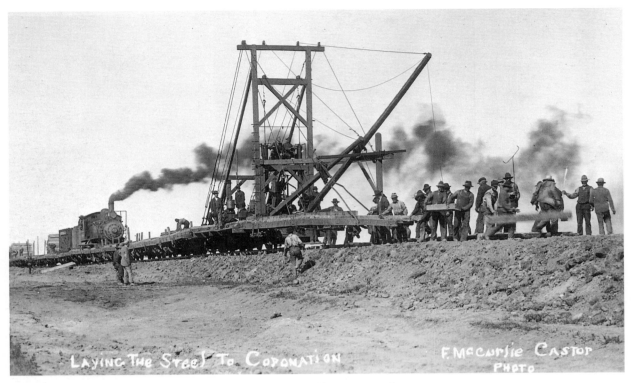

"Laying The Steel To Coronation"
Castor, AB
F. McCurlie / 1911
GLENBOW ARCHIVES, NA–698–3

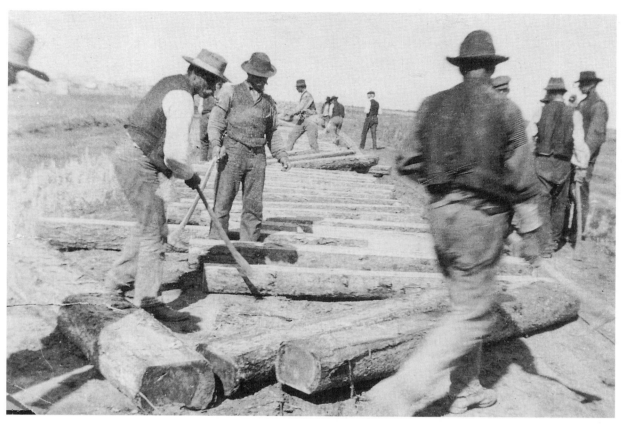

Laying ties on Canadian Northern Line between Saskatoon and
Lloydminster—many of the labourers were Barr Colonists
Photographer unknown / 1906–1907
GLENBOW ARCHIVES, NA–4514–10

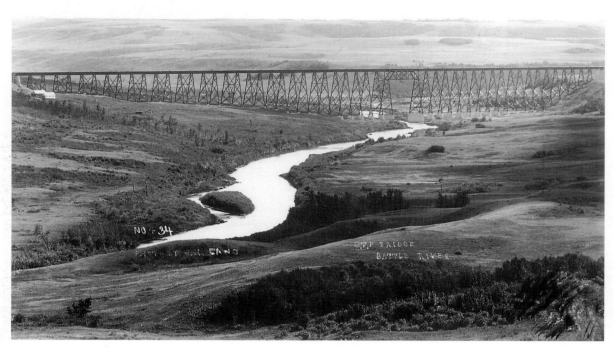

"G. T. P. Bridge, Battle River"
John Henry Gano / ca. 1910
GLENBOW ARCHIVES, NC–37–54

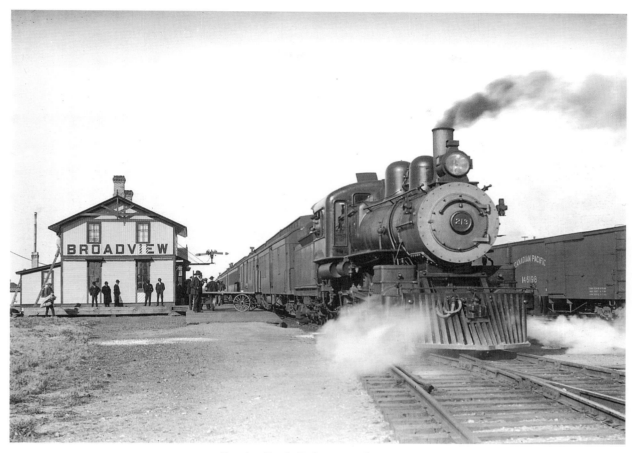

Canadian Pacific Railway steam locomotive
Broadview, SK
Herbert W. Gleason / 26 September 1905
Glenbow Archives, NC–53–86

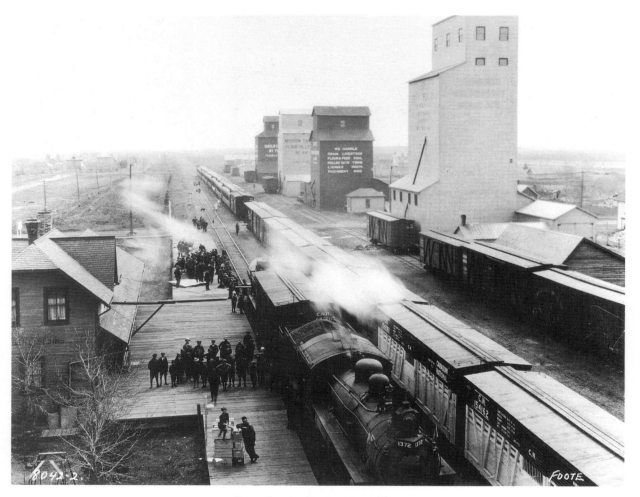

Better Farming Demonstration Train
Gilbert Plains, MB
Lewis B. Foote / 17 May 1923
Provincial Archives of Manitoba, N2618

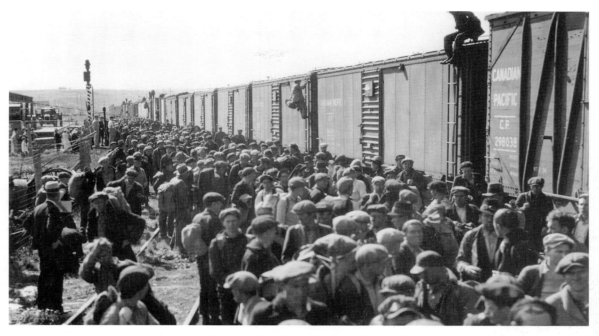

Unemployed men boarding trains, On-to-Ottawa Trek
Calgary, AB
Photographer unknown / 1935
SASKATCHEWAN ARCHIVES BOARD, REGINA RIOT INQUIRY, R–B3485(1)

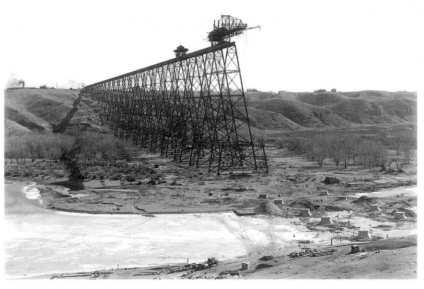

Construction of viaduct / railway bridge—1 mile long and 300 feet high
Lethbridge, AB
John Henry Gano / ca. 1909
GLENBOW ARCHIVES, NC–2–269

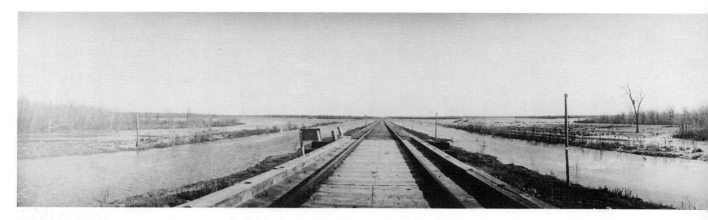

Flooded land along railway track—panorama
Near Ashdown, MB
Leslie G. Saunders / ca. 1930
UNIVERSITY OF SASKATCHEWAN ARCHIVES, LESLIE G. SAUNDERS
FONDS, FILE VIII.3

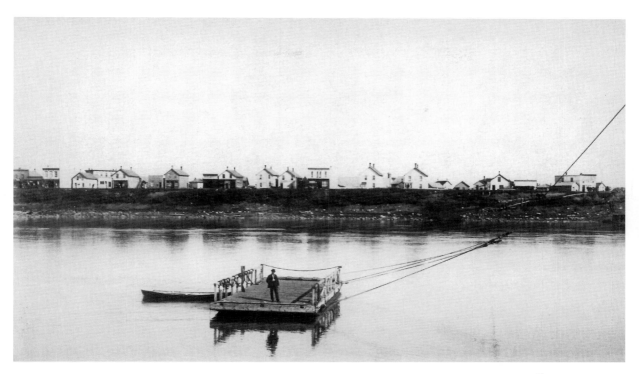

Ferry
Prince Albert, SK
Cornelius J. Soule (attrib.) /1884
B. SILVERSIDES COLLECTION

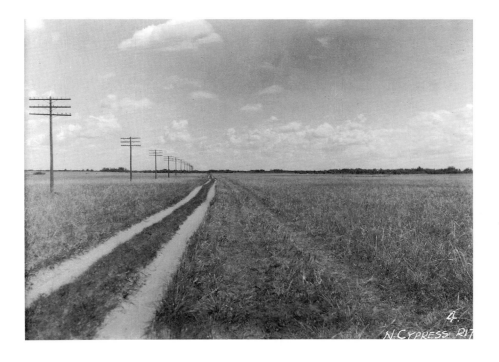

"North Cypress R-17"—section
of what would become the
Trans-Canada Highway
Near Carberry, MB
Photographer unknown / n.d.
PROVINCIAL ARCHIVES OF
MANITOBA (HIGHWAYS
COLLECTION R17–5)

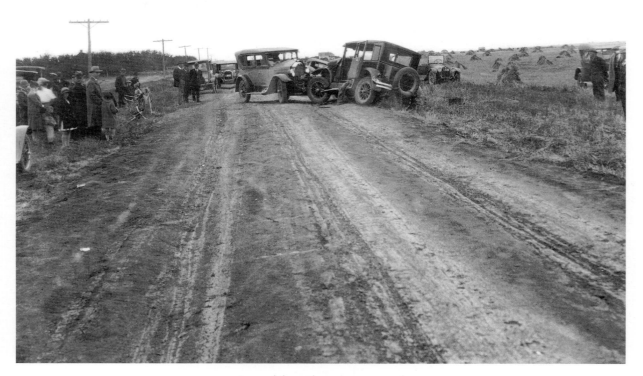

Automobile accident on country road
Regina district, SK
Wilfred West (attrib.) / ca. 1920
SASKATCHEWAN ARCHIVES BOARD, R–B4028(3)

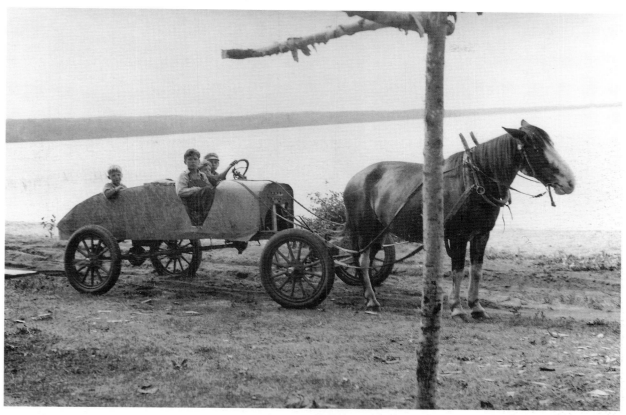

Bennett Buggy
Emma Lake, SK
Frederick E. Wait / ca. 1935
SASKATOON PUBLIC LIBRARY—
LOCAL HISTORY DEPARTMENT, #LH5315

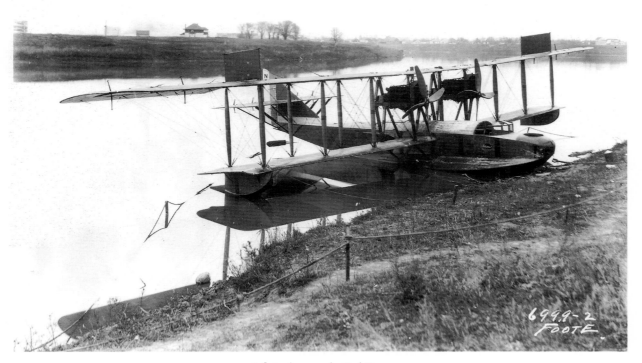

A flying boat on the Red River
St. Vital, MB
Lewis B. Foote / 13 October 1920
PROVINCIAL ARCHIVES OF MANITOBA, N2494

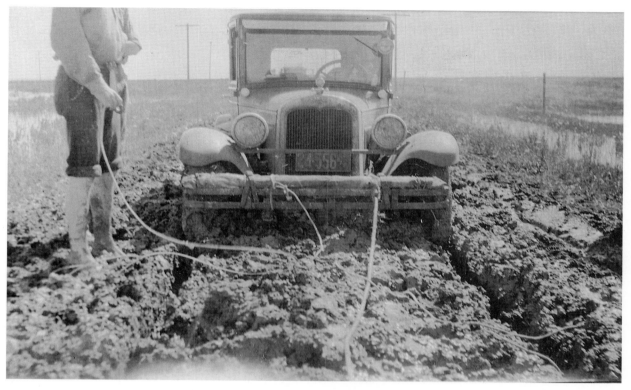

Automobile stuck on prairie road
Location unknown
Kathleen Parkin / ca. 1925
SASKATOON PUBLIC LIBRARY—
LOCAL HISTORY DEPARTMENT, PH 95–17–17

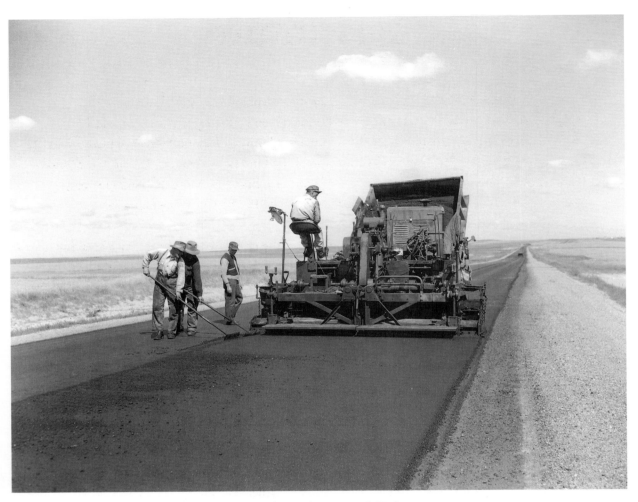

Laying blacktop on Trans-Canada Highway
Near Swift Current, SK
Olive B. Roberts / Saskatchewan Government Photo Services / August 1954
Saskatchewan Archives Board, 54–161–05

Agriculture

Photography has been fundamental to the documentation of agriculture on the prairies. It was first commonly used in research undertaken by the federal and provincial departments of agriculture, the three provincial universities, and by special institutions such as the Dominion Experimental Farms (established in 1886 at Brandon, Indian Head, and Lethbridge), Dominion Research Stations at Winnipeg, Brandon, Morden, Swift Current, Melfort, Lethbridge, Beaverlodge, and Lacombe, and the Prairie Farm Rehabilitation Administration.

An accumulated stock of photographs documents the cycles of agriculture, from breaking and ploughing to seeding, harrowing, weeding, swathing, binding, and later combining, as well as animal husbandry. These photographs were used in classroom and community hall lectures, in scholarly journals such as *Scientific Agriculture/La Revue Agronomique Canadienne* and *Agricultural Institute Review*, both national publications, and in popular magazines such as *Farm and Ranch Review* (Calgary), *Country Guide* (Winnipeg), *Farmer's Advocate* (Winnipeg), and the *Western Producer* (Saskatoon).

They also appeared in pamphlets, bulletins, annual reports, and a surprising number of locally written and published textbooks and manuals. John Bracken, professor of field husbandry at the Manitoba Agricultural College, and premier of Manitoba for twenty years, wrote two books—*Crop Production in Western Canada* (1920) and *Dry Farming in Western Canada* (1921)—that used these photographs, while Seager Wheeler of Rosthern, SK, five-time world champion wheat grower, produced an influential best-seller called *Seager Wheeler's Book on Profitable Grain Growing* (1919).

H. C. Andrews, a teacher at Scott Collegiate in Regina, wrote *Prairie Agriculture for High Schools* in 1927, which made it into the hands of most high school farm kids across Manitoba, Saskatchewan, and Alberta. In his introduction, he stressed the value of photographs:

> A great deal has been added to the value and attractiveness of the book by the use of many illustrations loaned by the Publications Branch, and the *Grain Growers Guide*, Winnipeg, The Seed Branch and the Entomological Branch, Department of Agriculture, Ottawa, The Live Stock Branch, and the International Harvester Company, Regina, and the Massey-Harris Company, Toronto.

An overview of farming in photographs constitutes an overview of the development of the prairie economy, culture, and the land itself.

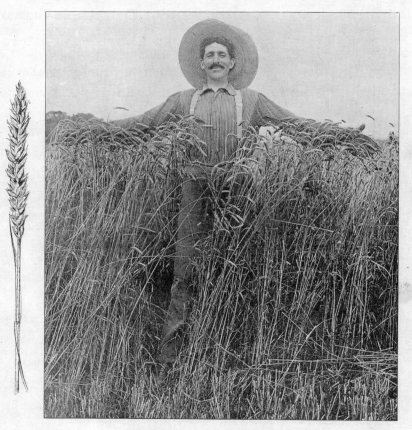

Cover of Nor'-West Farmer
5 July 1911

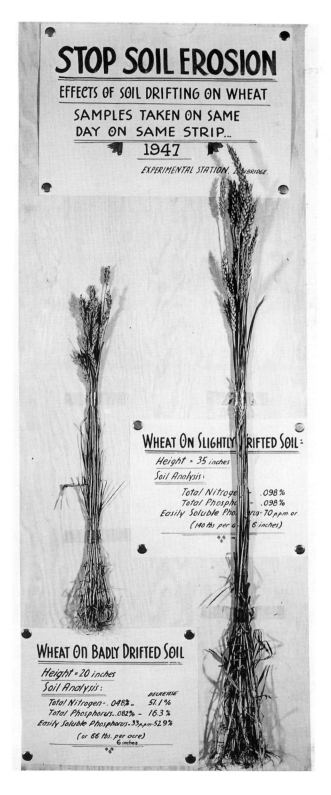

"Stop Soil Erosion"—
photograph of wheat stocks
from drifted soil
Lethbridge Experimental
Station, AB
Photographer unknown / 1947
MEDICINE HAT MUSEUM &
ART GALLERY, PC699.12

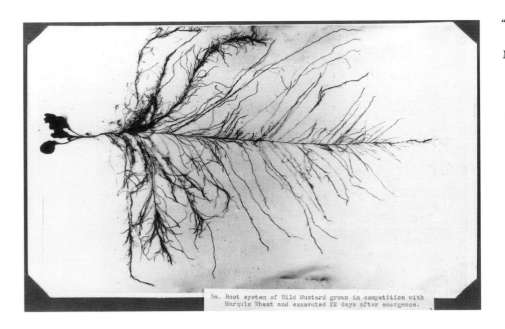

5a. Root system of Wild Mustard grown in competition with Marquis Wheat and excavated 22 days after emergence.

"Root system of Wild Mustard grown in competition with Marquis Wheat and excavated 22 days after emergence"
University of Saskatchewan, Saskatoon
From the booklet "Struggle for Existence Between Crops & Weeds" by Dr. T. K. Pavlychenko / 1937
UNIVERSITY OF SASKATCHEWAN ARCHIVES, T. PAVLYCHENKO FONDS, MG 29, FILE 31

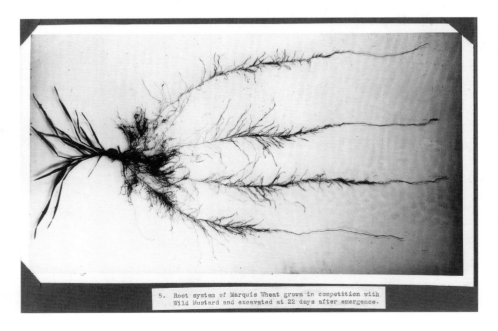

5. Root system of Marquis Wheat grown in competition with Wild Mustard and excavated at 22 days after emergence.

"Root System of Marquis Wheat grown in competition with Wild Mustard and excavated at 22 days after emergence"
University of Saskatchewan, Saskatoon
From the booklet "Struggle for Existence Between Crops & Weeds" by Dr. T. K. Pavlychenko / 1937
UNIVERSITY OF SASKATCHEWAN ARCHIVES, T. PAVLYCHENKO FONDS, MG 29, FILE 31

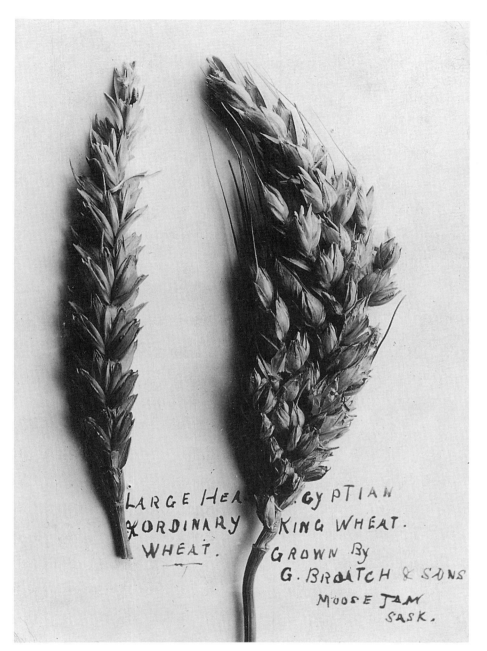

"Large Head Ordinary
Wheat —Egyptian King
Wheat. Grown G. Broatch & Sons"
Moose Jaw, SK
Photographer unknown / ca. 1912
B. SILVERSIDES COLLECTION

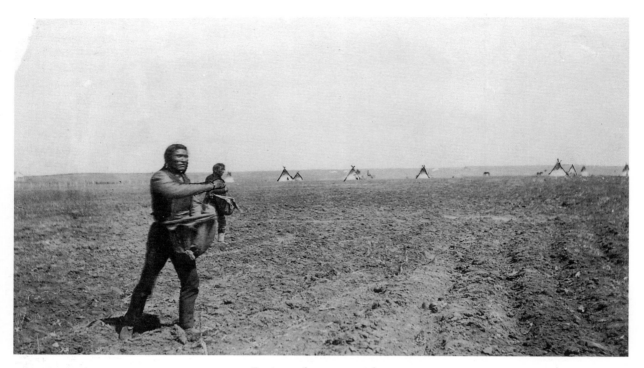

Sowing seeds on a reserve farm
Calgary district, AB
William Hanson Boorne / Boorne & May / ca. 1886
GLENBOW ARCHIVES, NA–127–1

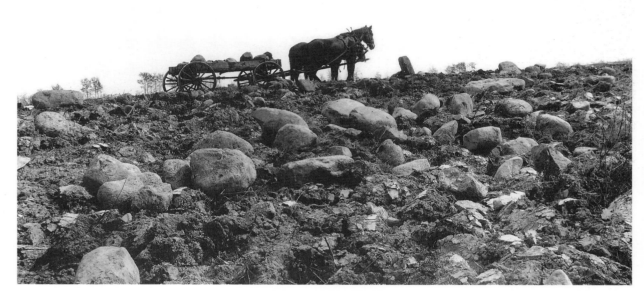

Picking rocks from a field
St. Luke district (near Whitewood), SK
John Howard / ca. 1910
SASKATCHEWAN ARCHIVES BOARD, R–B3031

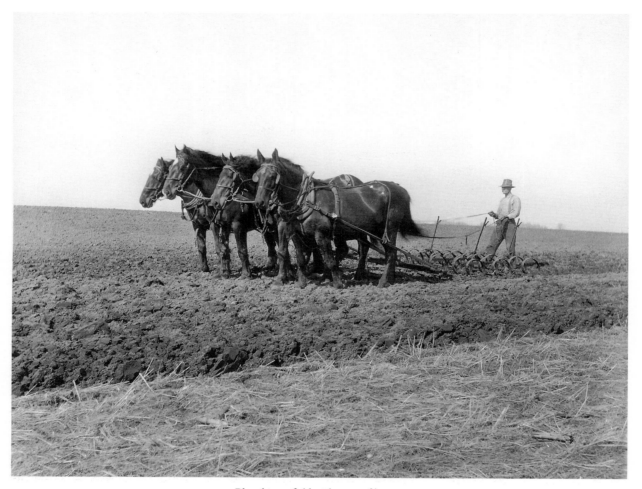

Ploughing a field with team of horses
Western Canada
Photographer unknown / ca. 1905
B. SILVERSIDES COLLECTION

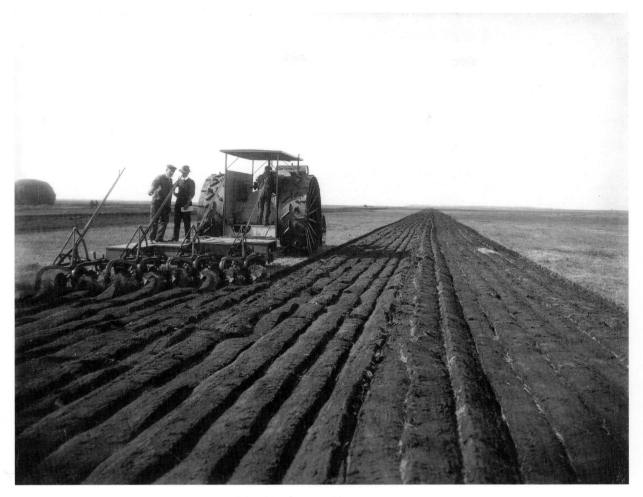

Ploughing furrows with steam tractor
Near Winnipeg, MB
Frederick Steele / Steele & Co. / ca. 1910
SASKATCHEWAN ARCHIVES BOARD, R–B1332

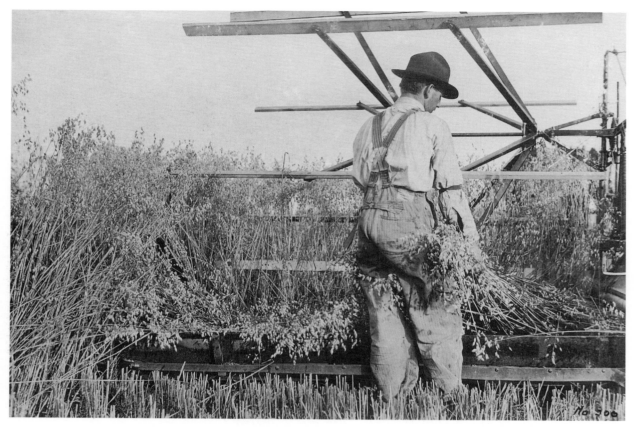

Swathing Oats
Near Edmonton, AB
Percy Byron / Byron & May / Fall 1912
GLENBOW ARCHIVES, NA–1328–300

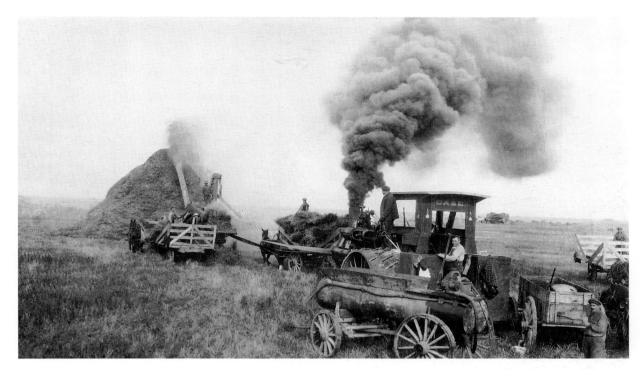

Threshing on the John Jago farm
Western Canada
Photographer unknown / ca. 1915
SASKATCHEWAN WESTERN DEVELOPMENT MUSEUMS, IF(D)–67

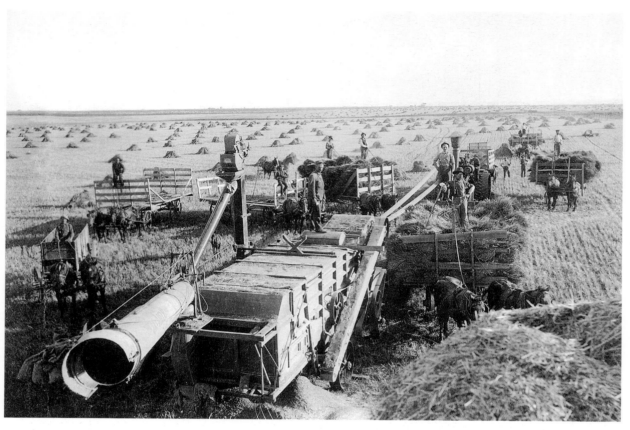

Threshing Outfit
Near Moose Jaw, SK
Photographer unknown / Fall 1906
GLENBOW ARCHIVES, NA–303–212

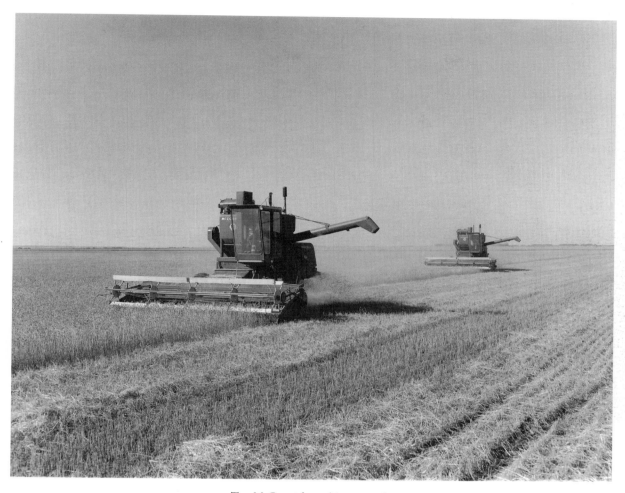

Two McCormick combines at work
Tessier, SK
Lester J. Smith / 21 September 1962
SASKATCHEWAN ARCHIVES BOARD, LESTER SMITH FONDS, BOX 2

"Bently Brothers (of hockey fame)
preparing their machinery for harvesting"
Delisle, SK
Photographer unknown / 2 September 1957
PRAIRIE FARM REHABILITATION ADMINISTRATION, #14220

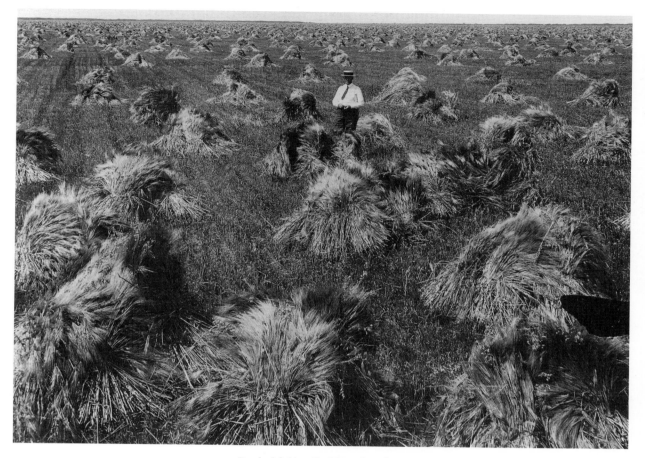

Stooked field on R. J. Hamilton farm
Near Brandon, MB
Lewis B. Foote / 22 August 1922
PROVINCIAL ARCHIVES OF MANITOBA (FOOTE COLLECTION 403)

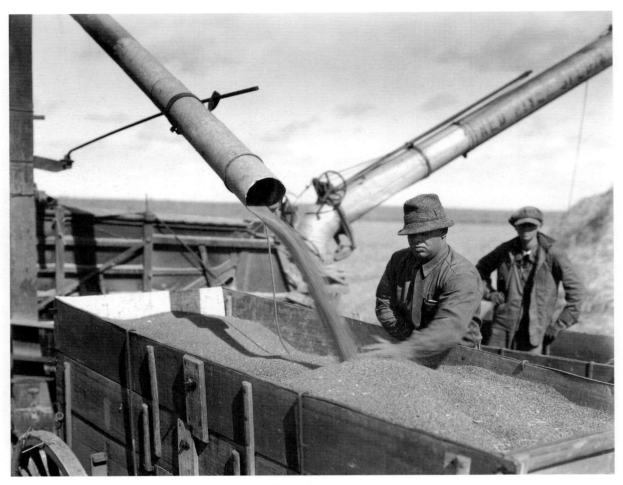

Loading grain into wagon
Near Coaldale, AB
William J. Oliver / ca. 1920
GLENBOW ARCHIVES, ND–8–210

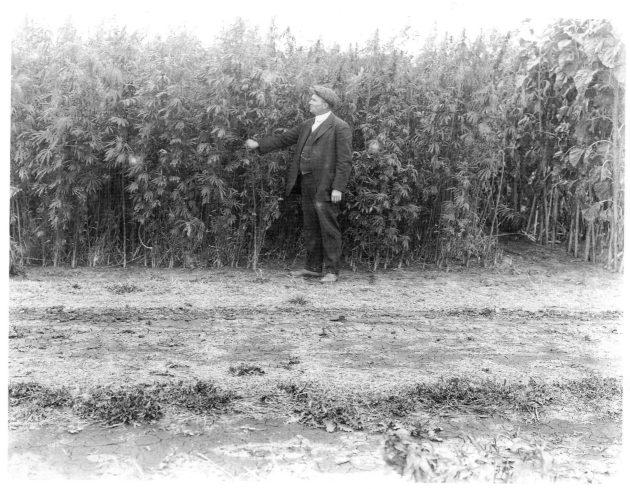

Hemp crop, Manitoba Agricultural College
Winnipeg, MB
Photographer unknown / 1920
PROVINCIAL ARCHIVES OF MANITOBA (AGRICULTURE—FARMS, HEMP I)

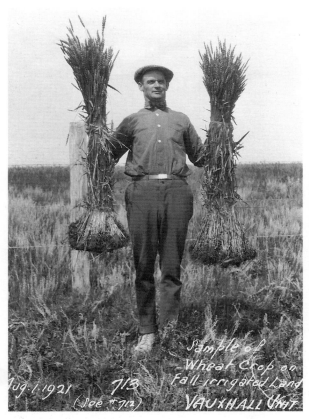

"Sample of Wheat Crop on Fall-Irrigated Land"
Vauxhall, AB
Photographer unknown / 1 August 1921
Prairie Farm Rehabilitation Administration #6765

"Sample Shock of Wheat"
Estevan, SK
Photographer unknown / 1908
B. Silversides Collection

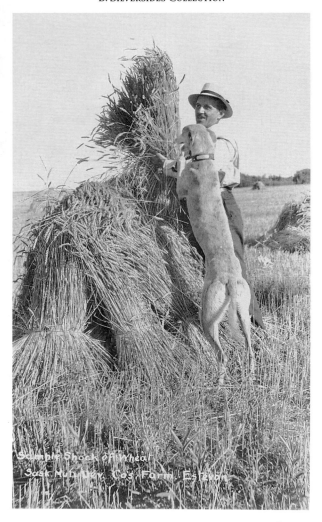

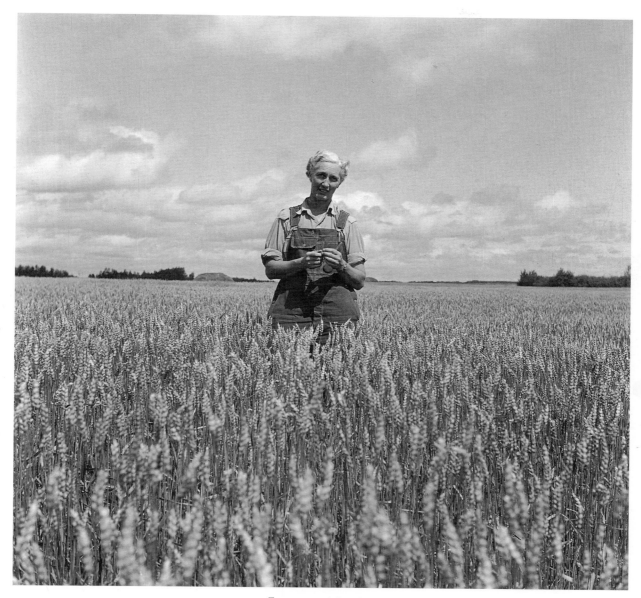

Farmer examining crop
Western Canada
Russell Holmes (Rusty) Macdonald / ca. 1950
SASKATCHEWAN ARCHIVES BOARD, S–RM–B1765

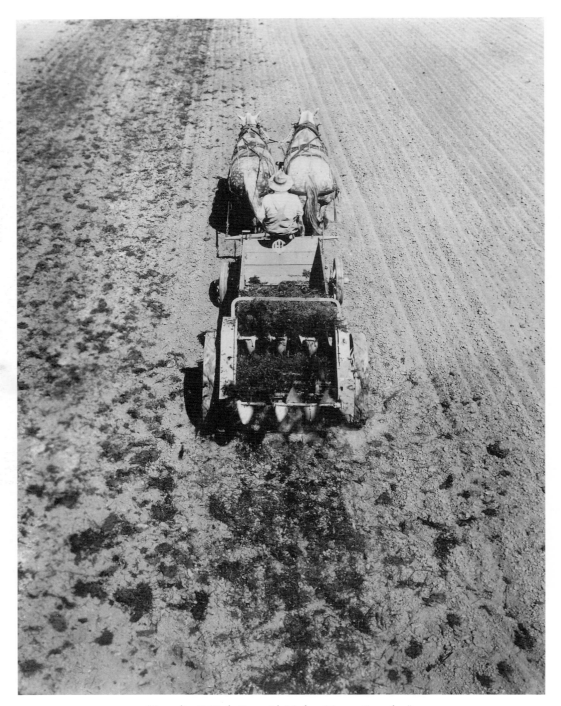

"Spreading It Made Easy with Modern Manure Spreaders"
Western Canada
International Harvester / ca. 1920
SASKATCHEWAN WESTERN DEVELOPMENT MUSEUMS, 2–(IHC) D(E)–I

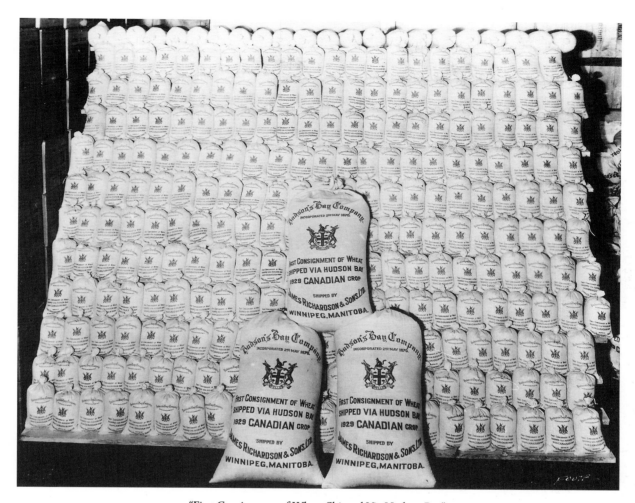

"First Consignment of Wheat Shipped Via Hudson Bay"
Winnipeg, MB
Lewis B. Foote / 1929
PROVINCIAL ARCHIVES OF MANITOBA, N2465

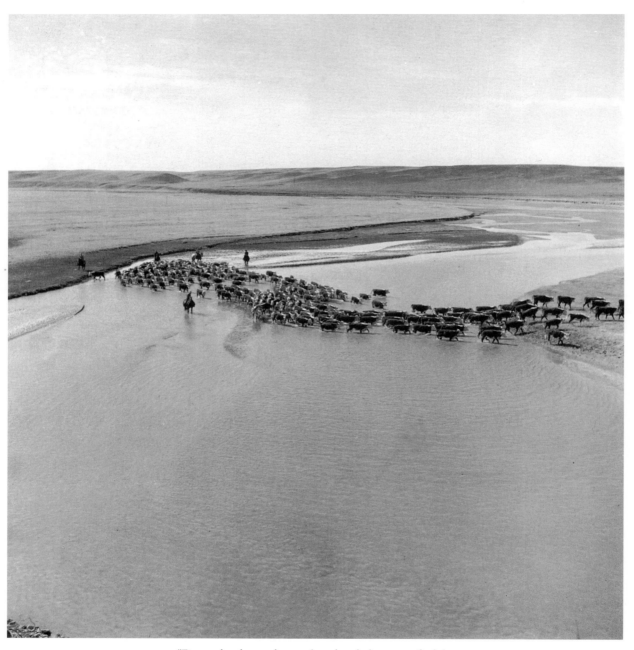

"Five cowhands round up cattle and push them on to ford the
Milk River"—bird's eye view of cattle drive
Southern Alberta
Harry Rowed / National Film Board Still Division / March 1944
NATIONAL ARCHIVES OF CANADA, PA–134188

Hereford eating into straw stack, Thode Ranch
Dundurn, SK
Cal Dean / Saskatchewan Government Photo Services / March 1961
Saskatchewan Archives Board, 60–864–11

Dehorning headgate—horns on the ground
Val Jean, SK
Alan Hill / Saskatchewan Government Photo Services / May 1957
SASKATCHEWAN ARCHIVES BOARD, 57–077–07

"Deep Cut, pot hole division, Galt Irrigation Canal System"
Near Lethbridge, AB
Photographer unknown / ca. 1900
GLENBOW ARCHIVES, NA–922–8

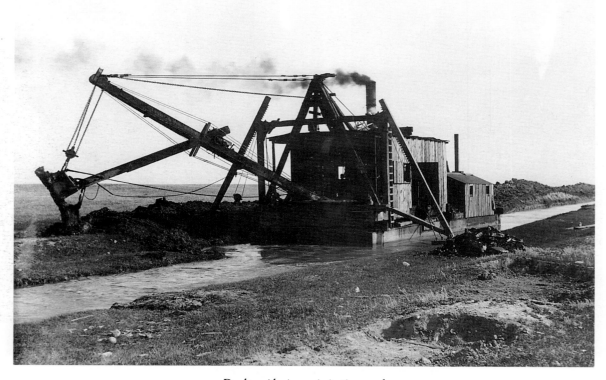

Dredge widening an irrigation canal
Near Lethbridge, AB
Photographer unknown / ca. 1898
GLENBOW ARCHIVES, NA–1323–16

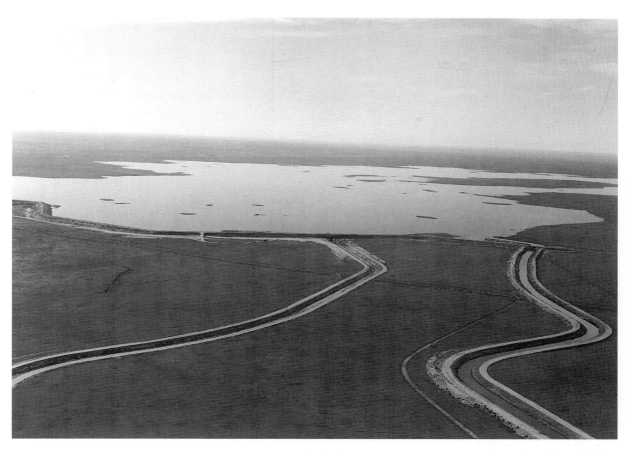

"Reservoir No. 1, P.F.R.A. Dam, Travers"
Near Hays, AB
Photographer unknown / 1953
PRAIRIE FARM REHABILITATION ADMINISTRATION #5592

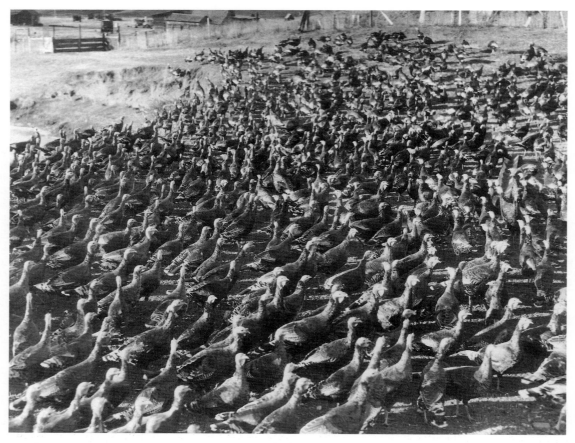

Turkey ranch
Ardenode, AB
William J. Oliver / ca. 1920
University of Saskatchewan Library Special Collections,
C565 / 2 / 11.18

Seager Wheeler with trophies
Saskatoon, SK
Ralph Dill / ca. 1918
SASKATOON PUBLIC LIBRARY—
LOCAL HISTORY DEPARTMENT, #LH1089

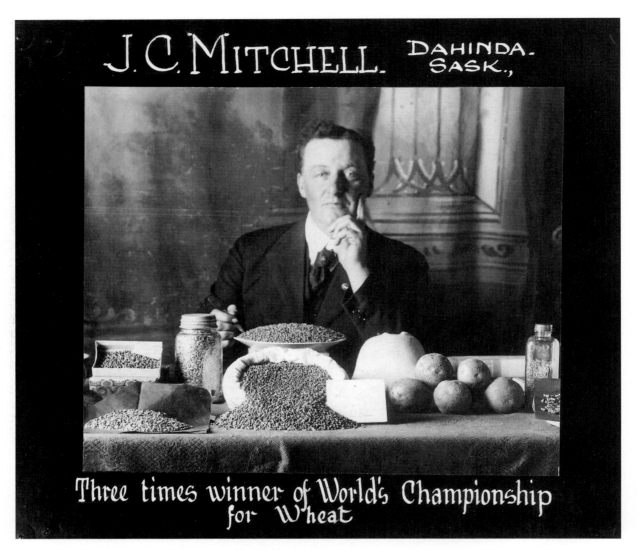

"J.C. Mitchell, Dahinda, Sask.—Three times winner of World's
Championship for Wheat"
Regina, SK
Photographer unknown / 1924
SASKATCHEWAN ARCHIVES BOARD, R–B442

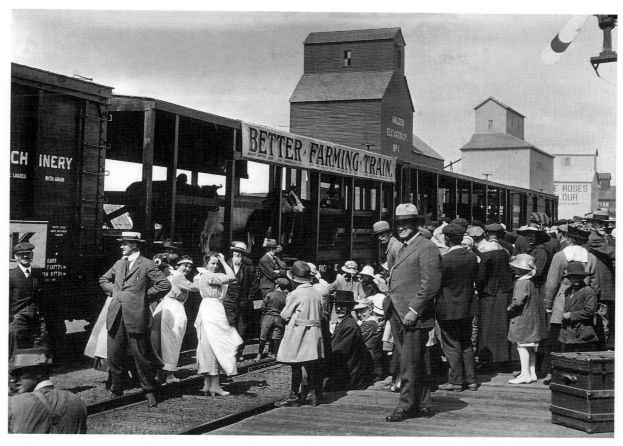

Better Farming Train stopping in a small Saskatchewan town
Location unknown
Photographer unknown / 1921
UNIVERSITY OF SASKATCHEWAN ARCHIVES, A–1422

**John Diefenbaker discussing the drought situation
and inspecting farm of A. V. Svoboda**
Cory Rural Municipality, SK
Russell Holmes (Rusty) Macdonald / 1 July 1958
SASKATCHEWAN ARCHIVES BOARD, S–RM–B2865

"Bales of Hay Form a Suitable Throne for this Young Farm Lass"
Location unknown
Olive B. Roberts / Saskatchewan Government Photo Services / July 1960
SASKATCHEWAN ARCHIVES BOARD, 60–265–09

Above and Below

Though you can usually see the horizon on the prairies no matter where you stand, perhaps the only way to take in its enormity and grandeur is to view it from the air. It is only from a height that one can see the fabled checkerboard that has resulted from the division of the land into sections and quarter sections, outlined by the ubiquitous and necessary grid roads.

From the air, all the natural features that seem so subtle at ground level suddenly emerge, whole and comprehensible. The shifting river beds and valleys, the gradations of vegetation, the intermittent sand dunes, the pock-marked glacial scrapings: all show a compelling view of both the present and the past.

The prairie region is blessed with an incomparable amount, quality, and variety of sunlight, from the warm glow of early morning to the implacable blaze of mid-afternoon to the deep and comforting—or garish and savage—sunset. For the big sky can be frightening. Winds run unimpeded in cyclones, tornadoes, and dust storms, and the lightning and thunder, hail and rain, can destroy a year's or a lifetime's work in a matter of seconds.

Beneath the earth, it is a similar story. Normally, the prairie landscape appears calm, stable, yet beneath the sod are pressures and forces that have been building for millennia. Oil and natural gas deposits are found throughout the region. Coal is found in all three provinces, sometimes near the surface, but much of it buried deep. Potash and sodium sulphate, and other materials such as clay and sandstone, represent large sectors of the prairie economy.

Humankind has also seen fit to bury much of the infrastructure needed to carry on a civilized life. Thus, the prairie is cross-hatched with a surprising number of oil and gas pipelines, water mains, irrigation lines, sewers, and power cables.

And in the end, all prairie dwellers—animal, plant, and human—eventually return to the earth that defined most of their lives.

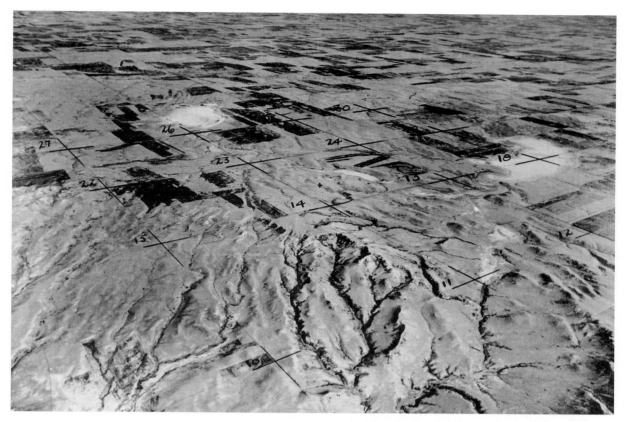

Aerial mapping of Twp. 4 Rgs. 9–10, west of the 3rd meridian—shows
water courses leading into Frenchman River
Near Val Marie, SK
Original image by RCAF; copy with grid overlay by Len Hillyard / n.d.
SASKATCHEWAN ARCHIVES BOARD, R–B1132

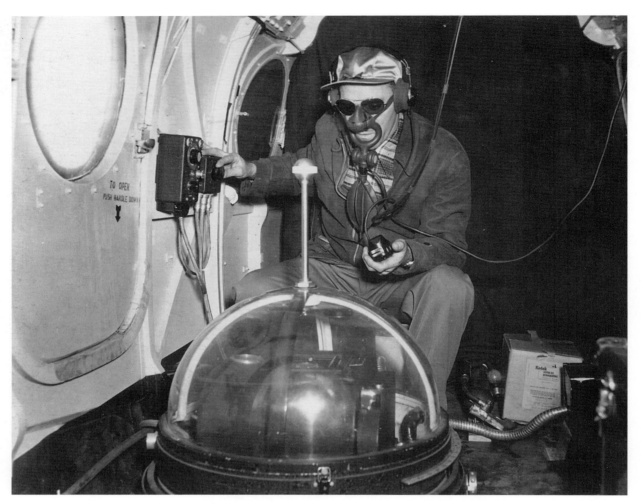

Aerial photographer operating vertical camera with remote shutter
Somewhere over Saskatchewan
Photographer unknown / ca. 1950
SASKATCHEWAN ARCHIVES BOARD, R–B2361

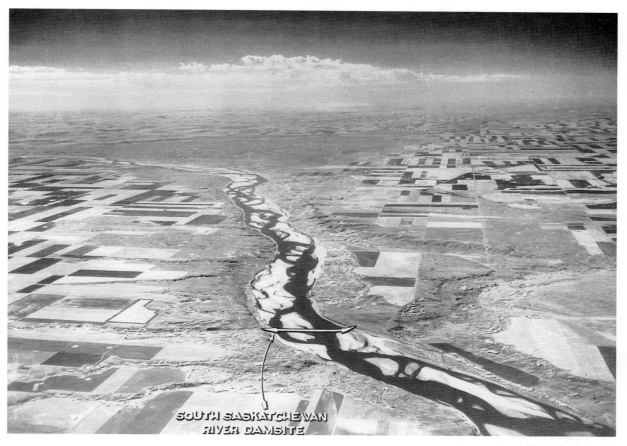

"South Saskatchewan River Damsite"—aerial oblique view
Near Outlook, SK
Photographer unknown / September 1958
PRAIRIE FARM REHABILITATION ADMINISTRATION, #16604

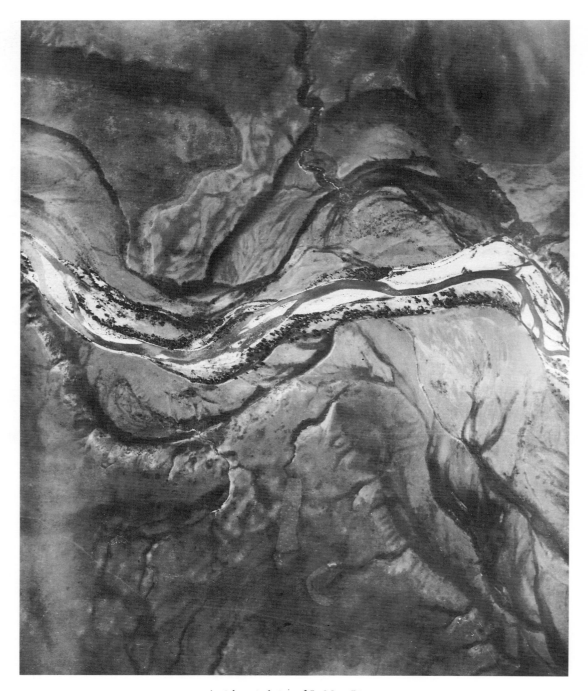

Aerial vertical view of St. Mary River
Over Blood Reserve, AB
Royal Canadian Air Force / 1922
AIR PHOTO SERVICES, ALBERTA ENVIRONMENT, C4A5–1922

Aerial vertical view of Range 11—a few miles north of the US border
Near Aden, AB
Royal Canadian Air Force / 1949
AIR PHOTO SERVICES, ALBERTA ENVIRONMENT, AS–185–4903–193

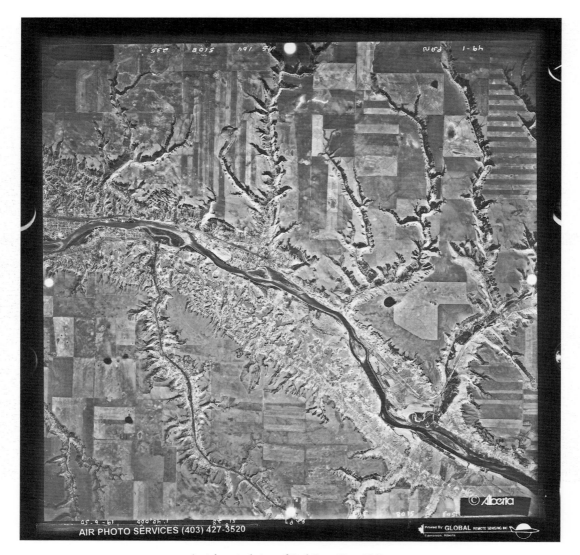

Aerial vertical view of Red Deer River Valley
Over Drumheller, AB
Royal Canadian Air Force / 1949
AIR PHOTO SERVICES, ALBERTA ENVIRONMENT, AS–164–5108–235

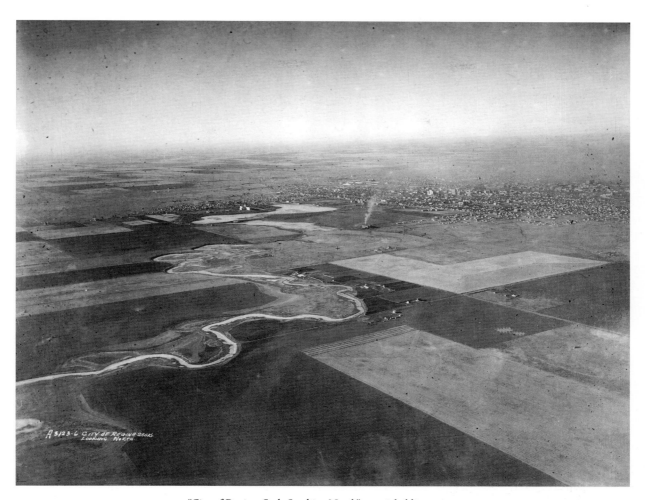

"City of Regina, Sask. Looking North"—aerial oblique view
Regina, SK
Royal Canadian Air Force / 8–9 November 1930
SASKATCHEWAN ARCHIVES BOARD, R–B770(6)

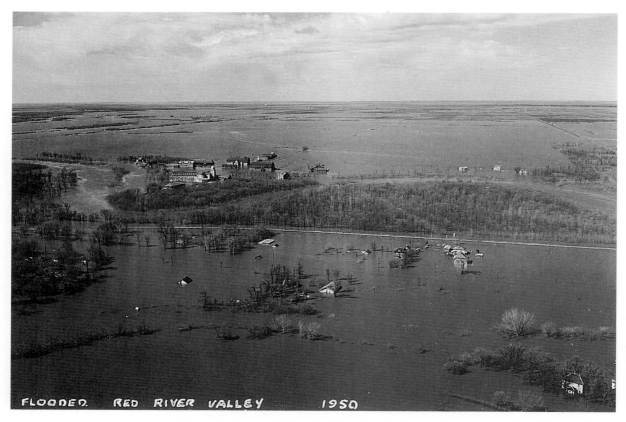

"Flooded Red River Valley"
Photographer unknown / 1950
B. Silversides Collection

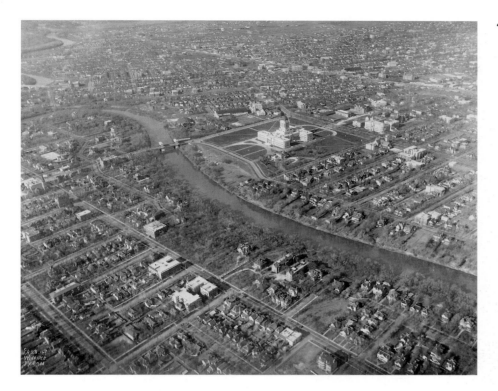

"Winnipeg, Manitoba"—aerial
oblique of downtown
Winnipeg, MB
Royal Canadian Air Force /
1923
B. SILVERSIDES COLLECTION

"View From East of Elbow
Showing town with Sask.
River in Background"
Elbow, SK
Olive B. Roberts / July 1963
SASKATCHEWAN ARCHIVES
BOARD, 63–246–109

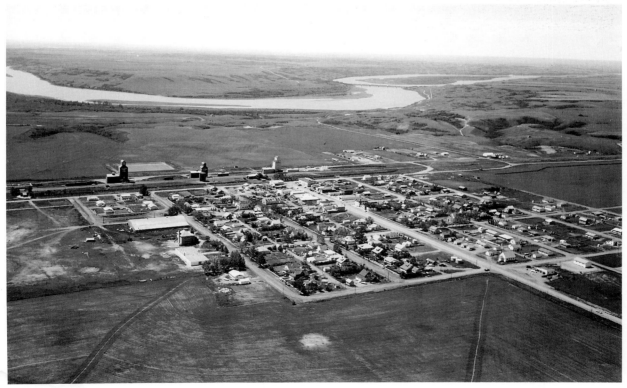

"View of Ice Jam at the Saskatchewan Landing Bridge, located
on Highway No. 4, North of Swift Current, Sask." Two days
after this picture was taken the ice took out the bridge,
which was rebuilt the following year.
South Saskatchewan River, SK
Saskatchewan Government Photo Services / 5 April 1952
Saskatchewan Archives Board, EA–103

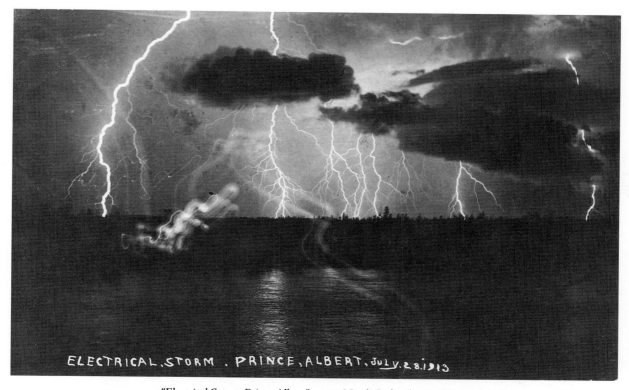

"Electrical Storm. Prince Albert"—over North Saskatchewan River
Prince Albert, SK
Photographer unknown/ 28 July 1913
B. Silversides Collection

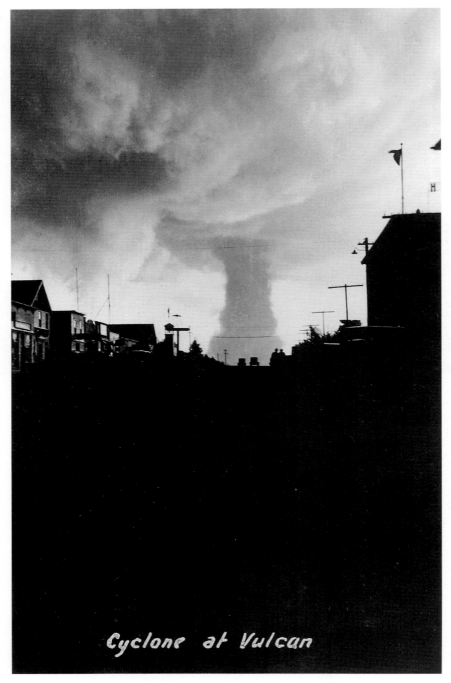

"Cyclone at Vulcan"
Vulcan, AB
McDermid Photo Laboratories / 8 July 1927
SASKATOON PUBLIC LIBRARY—
LOCAL HISTORY DEPARTMENT, #PH 91–286.2

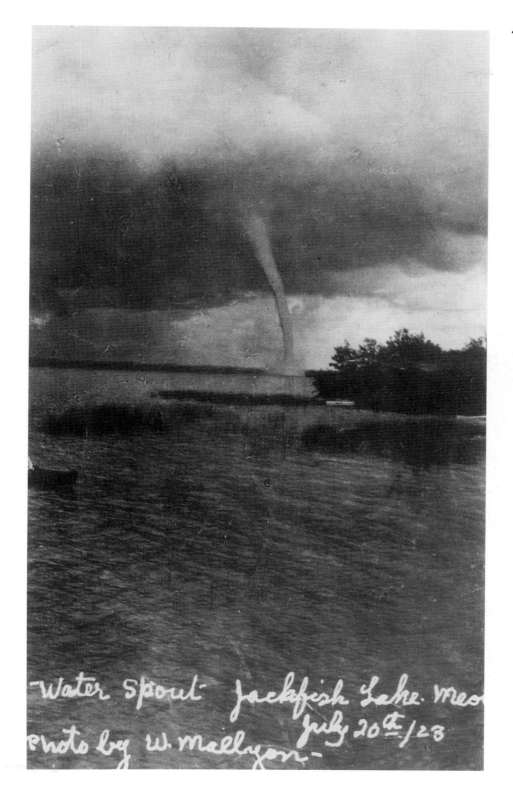

"Water Spout, Jackfish Lake.
Meota"
Near Meota, SK
W. Mallyon / 20 July 1928
SASKATCHEWAN ARCHIVES
BOARD, S–B5118

Commonwealth Air Training Program—aircraft from C.F.B. Moose Jaw
Somewhere over Saskatchewan
Russell Holmes (Rusty) Macdonald / 1941
SASKATCHEWAN ARCHIVES BOARD, S–RM–B391

Paratroopers of the No. 1 Light Battery drop from the sky during
Operation "Prairie Oyster"
Dundurn, SK
Russell Holmes (Rusty) Macdonald / 21 June 1952
SASKATCHEWAN ARCHIVES BOARD, S–RM–B1037

Quarrying sandstone
Tyndall, MB
Lewis B. Foote / 1929
PROVINCIAL ARCHIVES OF MANITOBA, N1881

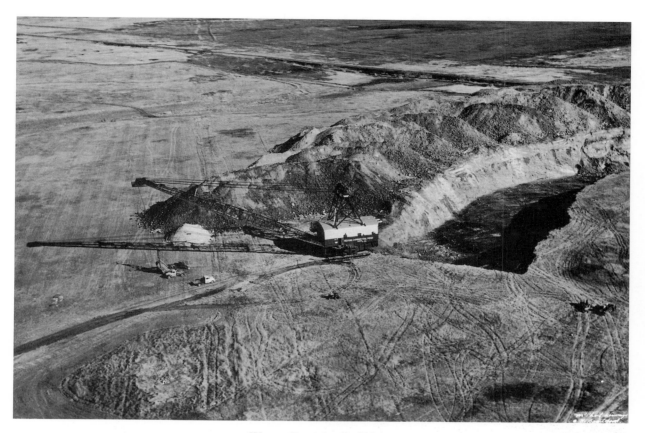

Western Dominion Coal Mines
Taylorton, SK
Hugh McPhail / McPhail Airways / 1955
SASKATCHEWAN ARCHIVES BOARD, S–B6106

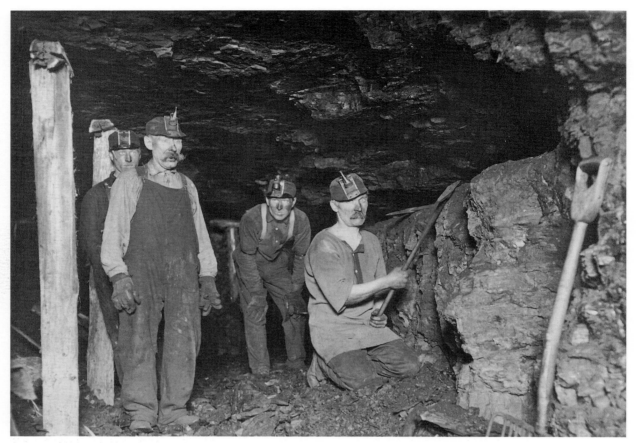

Coal miners
Estevan, SK
Photographer unknown / 1912
SASKATCHEWAN WESTERN DEVELOPMENT MUSEUMS, 6–B–1

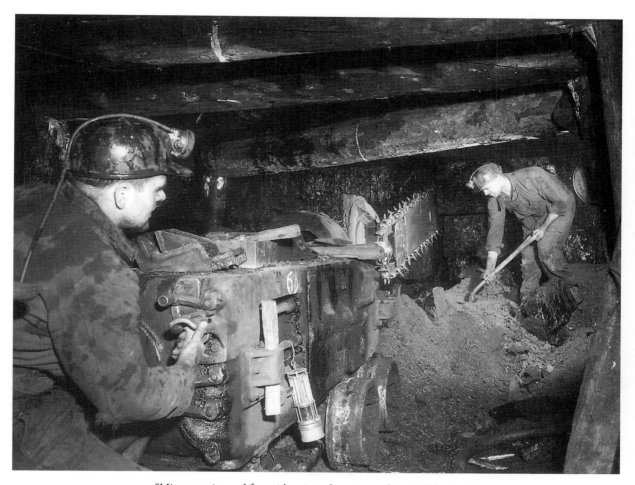

"Miners cutting coal face with universal cutting machine in Galt mines"
Lethbridge, AB
Orville Brunelle / April 1954
GLENBOW ARCHIVES, NA–4510–487

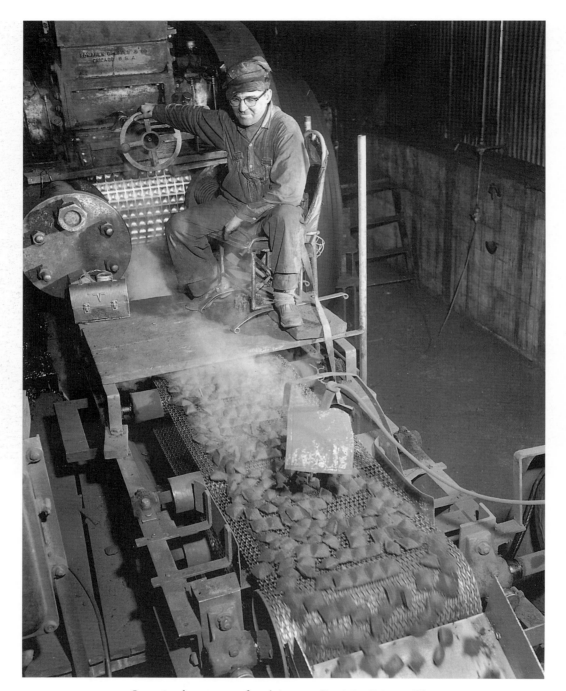

Operating drum press to form briquettes, Dominion Briquette Plant
Bienfait, SK
Cal Dean / Saskatchewan Government Photo Services / May 1961
Saskatchewan Archives Board, 61–137–08

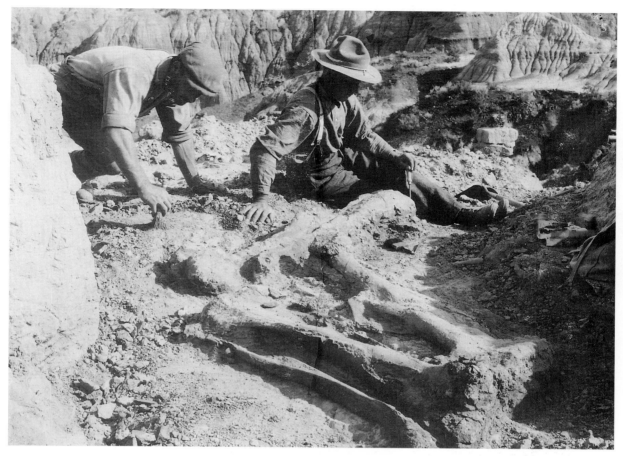

George Sternberg and Mr. Kelly uncovering long buried dinosaur
Steveville, AB
Photographer unknown / 1921
GLENBOW ARCHIVES, NA-3250-8

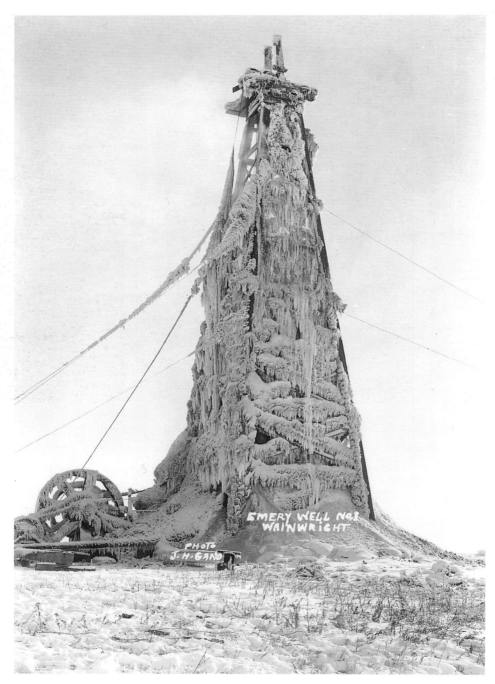

"Emery Well No. 1"
Wainwright, AB
John Henry Gano / ca. 1920
GLENBOW ARCHIVES, NC–37–28

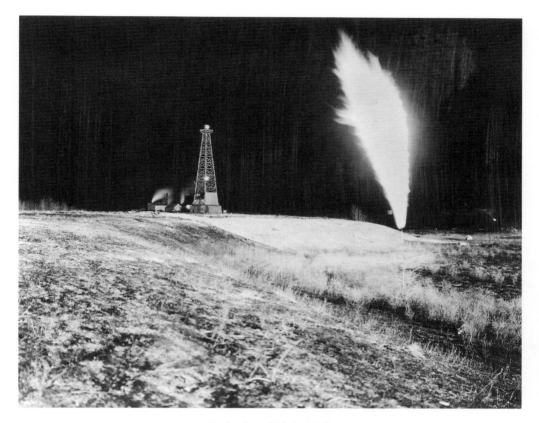

Night shot of Okalta Well
Turner Valley, AB
William J. Oliver / ca. 1930
GLENBOW ARCHIVES, NB–16–601

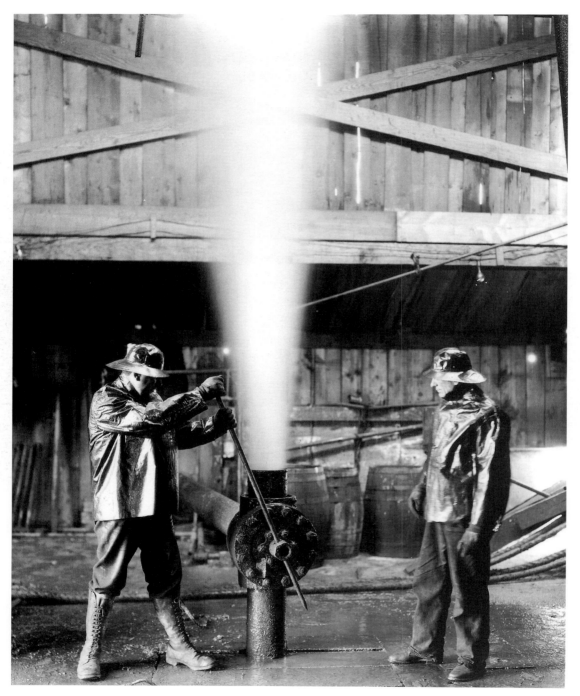

Home Oil Co. #1—blowing off gas to reduce pressure
Southern Alberta
William J. Oliver / 9 June 1927
GLENBOW ARCHIVES, ND–8–445

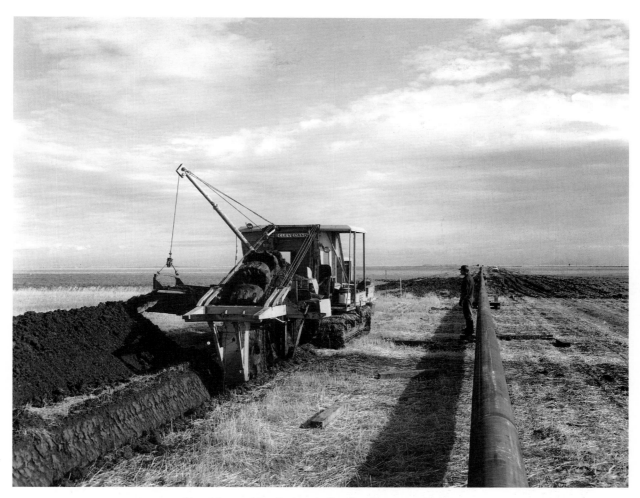

Trenching machine digging pipeline from Centaur to Regina
Near Pense, SK
Gerry Savage / Saskatchewan Government Photo Services / November 1954
SASKATCHEWAN ARCHIVES BOARD, 54–217–06

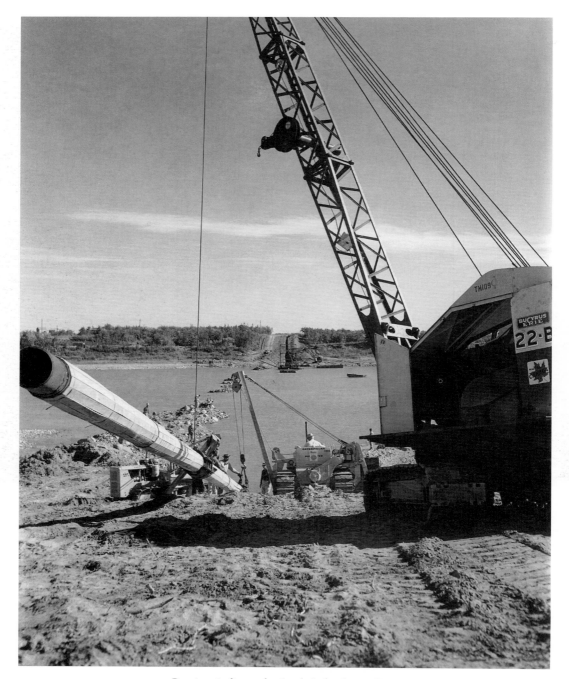

Burying pipeline under South Saskatchewan River
Near St. Louis, SK
Gerry Savage / Saskatchewan Government Photo Services / September 1955
SASKATCHEWAN ARCHIVES BOARD, 55-305-15

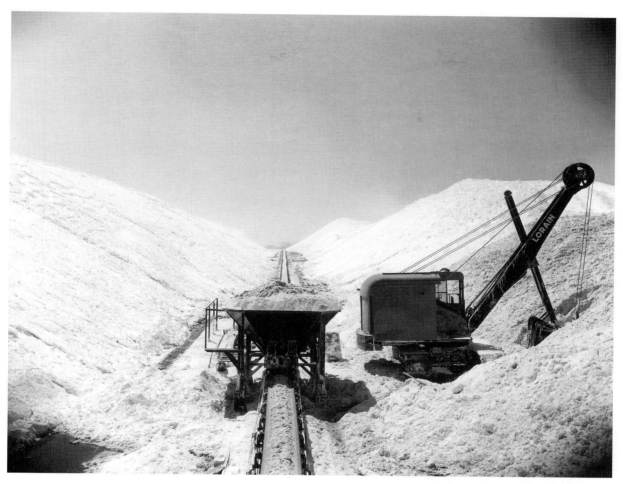

Sodium Sulphate Plant
Chaplin, SK
Vern Kent / Saskatchewan Government Photo Service / ca. 1958
SASKATCHEWAN ARCHIVES BOARD, 57–706–11

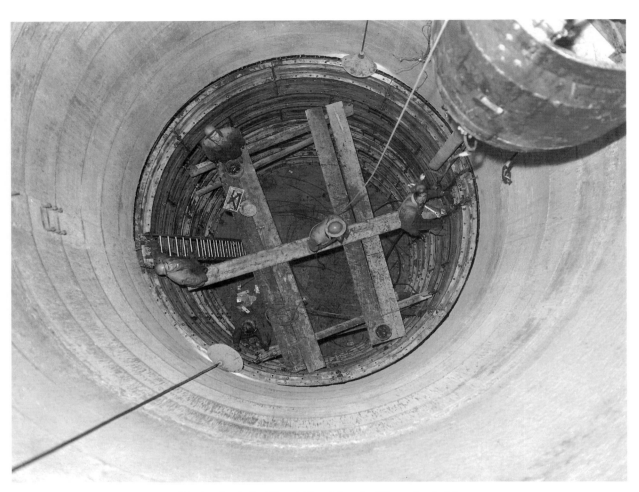

Digging the shaft of Potash Co. of America Mine—the shaft is
16 feet in diameter and would eventually go down 3,000 feet
Patience Lake, SK
Saskatoon *Star-Phoenix* / 21 March 1956
SASKATCHEWAN ARCHIVES BOARD, S–SP–267–2

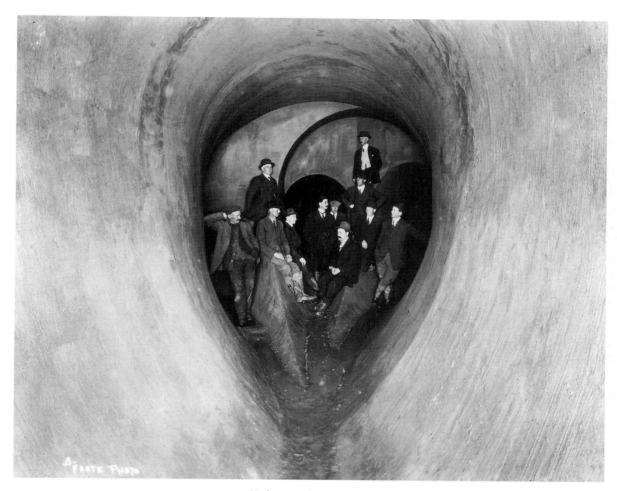

Underground water mains
Shoal Lake, MB
Lewis B. Foote / 1916
PROVINCIAL ARCHIVES OF MANITOBA, N2451

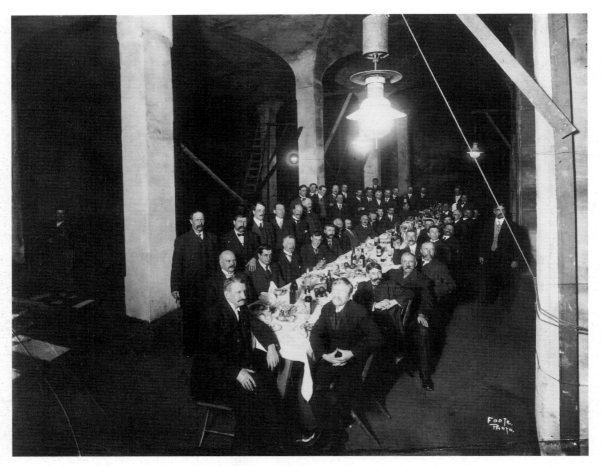

Civic banquet in sewer—celebrating completion of construction
St. Boniface, MB
Lewis B. Foote / 1912
PROVINCIAL ARCHIVES OF MANITOBA, N3012

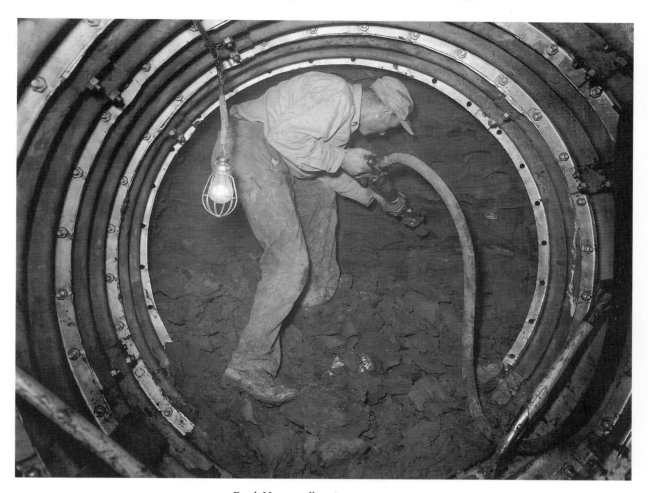

Frank Hepp sandhogging a storm sewer
Saskatoon, SK
Saskatoon *Star-Phoenix* / 27 June 1951
SASKATCHEWAN ARCHIVES BOARD, S–SP–740–3

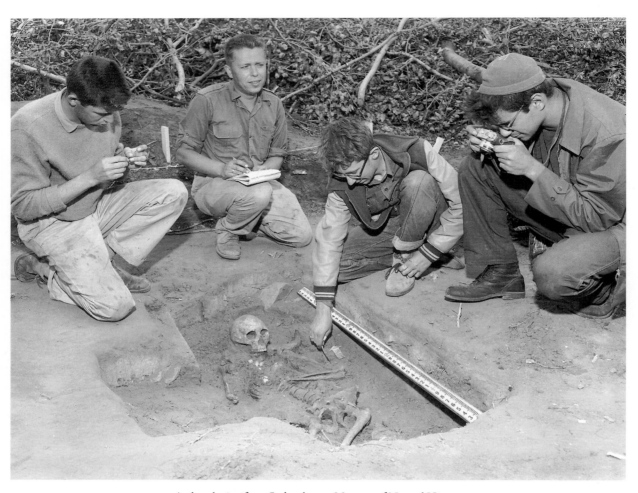

Archaeologists from Saskatchewan Museum of Natural History
uncovering unidentified grave—left to right: David Humphries,
Zenon Pohorecky, Ian Rodger, and Morgan Tamplin
Near Saskatoon, SK
Saskatoon *Star-Phoenix* / 10 July 1959
SASKATCHEWAN ARCHIVES BOARD, S–SP–5155–7